The Passion of Christ

Erika Swanson Geiss

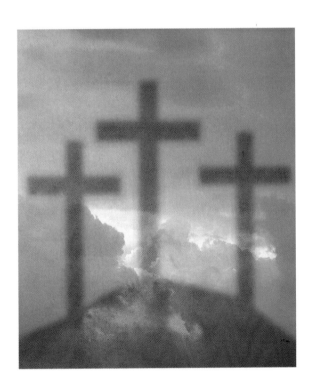

Publications International, Ltd.

Erika Swanson Geiss, M.A., is an art historian and editor. She has worked at the Museum of Fine Arts, Boston, where she was a contributing author to *Monet, Renoir and the Impressionist Landscape.* She was the Director of Education at the Rose Art Museum in Massachusetts. In addition, she held the position of visiting instructor in the Fine Arts Department at the University of New Hampshire, Durham. Currently, Ms. Geiss is a curatorial consultant at the Charles H. Wright Museum of African American History in Michigan.

Picture credits:

Front cover (center): **Erich Lessing/Art Resource**

Back cover: **Cameraphoto/Art Resource**

Art Resource: Alinari: 11, 19, 46, 53 (top), 82, 87, 115; Nicolo Orsi Battaglini: 18; Cameraphoto: 12, 13, 58, 64, 65, 68, 74, 75 (top), 76, 77, 80, 92, 103 (bottom), 104, 105, 117, 125; Giraudon: 48, 72, 122, 123; HIP/Scala: 86; Erich Lessing: 5 (bottom), 7, 15, 33, 51, 59 (top), 62, 63, 73, 81, 84, 89, 90, 94, 101, 109, 110, 113; The Philadelphia Museum of Art: 107; Réunion des Musées Nationaux: 39, 45, 70, 83, 120; Scala: 6, 9, 14, 17, 61, 67, 71, 75 (bottom), 85, 91, 93, 95, 99, 100, 102, 103 (top), 106, 112, 118, 119, 121, 126; **Bridgeman Art Library:** 26, 36, 42, 47, 49, 54, 56, 59 (bottom), 111; Giraudon: 34, 35, 55; Lauros-Giraudon: 44; Lawrence Steigrad Fine Arts, New York: 30; Roger-Viollet, Paris: 29; **©Corbis:** Archivo Iconografico, S.A.: 53 (bottom), 124; Arte & Immagini srl: 27, 97; Bass Museum of Art: 4, 31; Bettmann: 5 (top); Francis G. Mayer: 108; Richard T. Nowitz: 66; **SuperStock:** 21, 24, 25, 37, 41, 57, 79; ET Archive, London: 22; Lauros-Giraudon, Paris: 23.

All scripture quotations are taken from the New Revised Standard Version of the Bible. Copyright © 1989 by the Division of Christian Education of the National Council of the Churches of Christ in the United States of America. Used by permission. All rights reserved.

Louis Weber, CEO
Publications International, Ltd.
7373 North Cicero Avenue
Lincolnwood, Illinois 60712

Manufactured in U.S.A.

8 7 6 5 4 3 2 1

ISBN: 1-4127-1074-X

Library of Congress Control Number: 2004104096

Contents

The Art of the Passion

he last twelve hours of Jesus' life have come to be called the *Passion of Christ*. This period begins with the Last Supper, which coincided with Passover. Jesus and his disciples shared the Passover seder, and it is at this meal that he revealed to his twelve closest followers that one of them—Judas Iscariot—would betray him. The series of events that followed—from Jesus' betrayal by Judas to the high priests and court officials (who were already plotting to have him murdered) to his trial and sentence to death by crucifixion—proved to be pivotal in world and religious history.

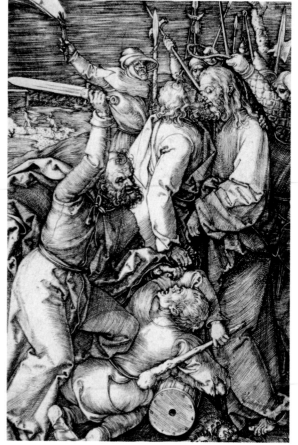

ALBRECHT DÜRER, Betrayal of Christ *(1508). This northern European work shows Judas betraying Jesus with a kiss in the midst of an angry mob.*

Until Jesus' death, there were no Christians in the world. Judaism was the only monotheistic religion, existing alongside several other religions and cults. The world that Christ lived in was under Roman rule, and some of the practiced religions were legal, while others were not. Those that were legal were permitted as long as their followers never equated their deity or deities as kings and therefore higher than the secular ruler.

As a religious event, Jesus' death defined the difference between those who believe that he is the Christ—the Messiah—whose divine mission is to free humankind from sin and eternal separation from God through his own death, and those who do not. After Jesus died, those who believed in him and the purpose of his death were not permitted to express their beliefs publicly. Early Christianity was practiced in a secret, cultlike manner, especially in the bloodthirsty Roman Empire. There, public demonstrations of Christian practices, such as preaching Jesus' words and works or partaking in re-creations of the Last Supper (the Eucharist), were punishable by martyrdom and death. It was not until A.D. 313, when Constantine legalized Christianity, that those who practiced were able to do so without fear. Yet, after nearly 300 years of secret practices, Christianity survived. To propel their message, Christians relied heavily on images of Christ, his miracles, and his teachings, especially for the largely illiterate population.

Between the centuries of Christ's death (which was about A.D. 28) and the fourteenth century, the Christian world underwent many changes and reforms. By the Renaissance, there

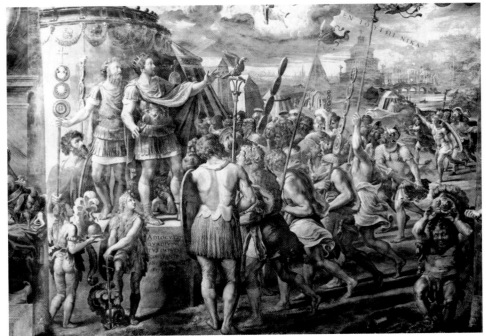

proportions in all things, and the artists of the Renaissance strove to reclaim its ancient glory (which was felt to have been lost during the Middle Ages, sometimes called the Dark Ages).

was a highly institutionalized Catholic Church with the Pope as its leader and figurehead. The church not only acted as a religious power, but it also held vast political and financial power, in part because many high-ranking clergy members were from ruling-class families (such as the Borghesse and the Medici).

The Renaissance, which is usually associated with Italy, is a period noted for its culture of rebirth of the *all'antica*, secular-humanist thought, as well as the counterpoint to secular humanism, religious fervor and influence. A large amount of devotional art (as well as art with historical and mythological themes) was created during the Renaissance on canvas, in fresco, in sculpture, and as part of architecture. Characterized by an interest in a revival of the ancient arts and letters, the quest for the *all'antica* involved seeking perfect harmony of

Architectural campaigns were created, not only for the glory of the cities that sponsored them (Florence, Rome, and Venice, for example), but also for the glory of the patrons and donors who did so. With so many private, civic, and religious buildings being renovated or erected, it

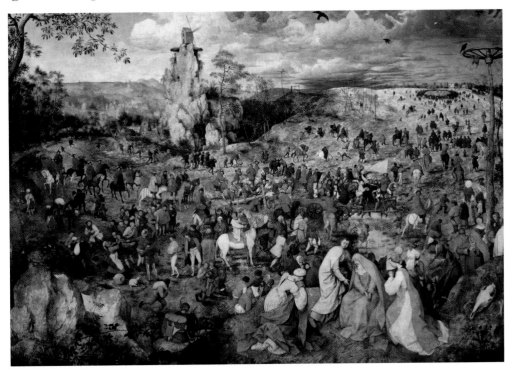

PETER BRUEGHEL THE ELDER, Jesus Carrying the Cross *or* The Way to Calvary (1564). *Although the main event here is Jesus carrying the cross, this typical northern European depiction includes a vast number of details and activities.*

was necessary to decorate these spaces. While secular histories and mythologies, along with portraits, were popular themes, sacred and religious images were as well, and they were commonplace in a Catholic (Christian) society, even in private homes.

Within the sacred realm of churches, chapels, and monasteries, the practice of having intricately detailed altarpieces and other smaller images was common. However, such commissions grew increasingly ample as the church (as an institution) used donations from wealthy patrons or from parish collections to build chapels or update existing buildings. Wealthy patrons sought to have chapels built and other large works donated in order to gain favorable posi-

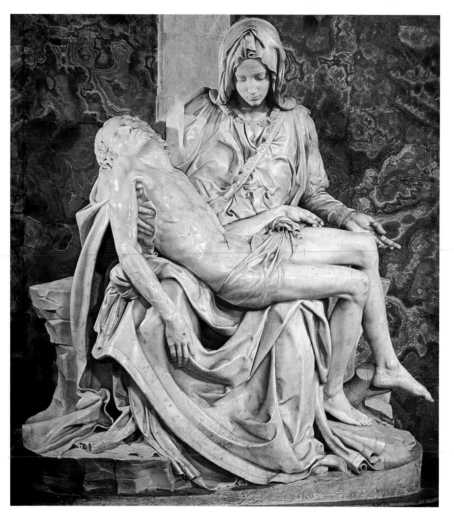

MICHELANGELO BUONARROTI, Pietá *(1498–99). This marble sculpture, created by an Italian master of the Renaissance, evokes the tender emotions felt when Mary cradles the body of her dead son.*

tions in heaven through financial support of the church. Yet such images also provided a benefit to worshipers who weren't wealthy. Sacred images became the "Bible of the illiterate," with the stories being told through images rather than words. The detailed narratives of scriptural stories reinforced the liturgy and also allowed parishioners and members of the clergy to identify with the suffering of saints and martyrs and, especially, the suffering of Jesus' Passion.

The art and architecture of the Renaissance and Baroque periods were produced not in a vacuum but as part of a wave of social, political, and religious changes and reform. For example, there was a competitive nature between artists from the north (the Netherlands and other parts of northern Europe) and the artists of the south (Italy). Italians believed in order, harmony, perfect proportions, and a cool restraint with respect to imagery; their northern counterparts believed in a more encyclopedic approach. Italian artists proved their artistic prowess through their abilities to draw and paint from the natural world. Northerners, on the other hand, exhibited their artistic strengths by depicting many details and a variety of objects, especially difficult ones such as glass, mirrors, and the reflections upon them.

Other differences between the two geographical regions relate to their relationship with the papacy and the church as an institution. While southerners were more closely allied with the papacy, northern reformers saw the church as becoming increasingly corrupted by money, human vanity, and power. They believed the church was losing sight of the true mission of

Christianity, and thus in 1520 the excommunicated Martin Luther addressed the Diet of Worms and formed the first sect of Protestants.

The Catholic Church was not immune to its own internal divisions. Groups broke off that followed stringent methods of practice and worship, such as the Jesuit Order, which formed in 1540. These splits did not arise without a greater response from the church, which in 1563 formed the Council of Trent, wherein rules were established (including ones for sacred images) that called for a more restrained, sober approach. Not all artists responded to the changes, although those who were closely allied with papal patrons (such as Michelangelo) did. Yet through the artists' works, one can still see an emotional approach to sacred imagery.

Religious and sacred scenes, probably more than any other imagery, allowed Renaissance and Baroque artists to expressively and creatively depict powerful emotions and themes while still working within the boundaries of their employers' demands. Artists could exhibit their abilities to cleverly express human emotions as intangible as faith, fear, anger, and sorrow, as well as the superhuman qualities of martyrs, saints, and—above all—Jesus Christ.

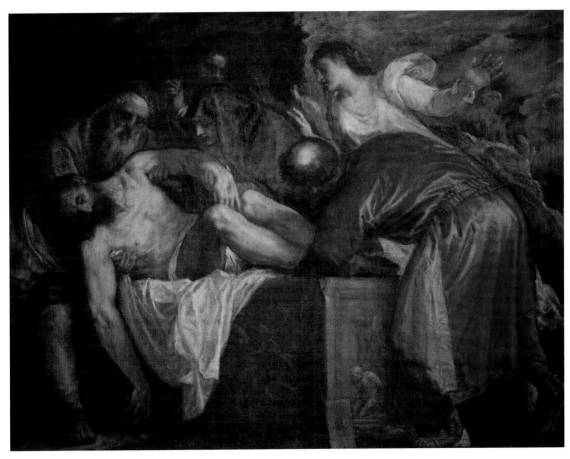

Central to the tenets of Christianity, the imagery surrounding the Passion of Christ is some of the most powerful. Both Renaissance and Baroque artists expressed the sheer pain of Jesus' torture, his suffering upon the cross, the agony of his mother, and the miracle of his resurrection and eventual transfiguration. The number of images of the Passion (and other religious imagery) is vast and can be tied to both its importance to the Christian faith and to the quantity of decorated churches, chapels, monasteries, and abbeys. Because of its mystery, the Passion of Christ is probably the single most defining event in human history. It still has the ability to bewilder, attract, inspire, and otherwise move those who view its depiction. Its power (religiously and visually) and mysterious nature have transcended periods and places and inspires us to this day.

TITIAN (TIZIANO VECELLI), The Entombment of Christ *(ca. 1566). This rich, focused portrayal of the entombment is done in a typical Italian style.*

A Pivotal Meal
THE LAST SUPPER

There are four biblical accounts of the events that transpired during the Last Supper. Matthew, Mark, Luke, and John all give slightly different versions of the story in their Gospels, yet what each one shares is that the Last Supper coincides with the first seder of Passover, and at that meal Jesus reveals to his disciples that one of them will betray him. It is not his first reference to being betrayed, for he does so (according to Matthew 26:2) even two days before Passover, after his sermon on the Mount of Olives. In the varying accounts of Jesus' declaration that this will occur, and that it is his destiny to be betrayed and die, some are quite specific—both Matthew and John say that it is Judas who will betray him—while in other cases Jesus makes a more general statement about the impending betrayal.

The Gospel of John also gives an account of Jesus humbling himself before his disciples. Stripping before them, except for his loincloth, he washes their feet with his own garments as a gesture to show that he is not their king (which he was accused of proclaiming), but rather their servant. Through this act, Jesus subtly teaches that they, too, should follow his example and be servants to all, to each other, and—most of all—to God.

Despite the difference in the four biblical accounts of the Last Supper, the events do align with historical events in such a way that scholars and historians have been able to trace the period to coincide with the feast of Passover. The intersection of Passover with the Last Supper is very symbolic: This meal that Christ shares with his disciples becomes a spiritual communion, the Eucharist, and the meaning behind Passover itself. Jesus offers bread as his body and wine as his blood, and his disciples partake in this communion with him.

Renaissance and Baroque artists used a variety of methods to express the symbolism of the Last Supper. Some chose to depict a straightforward narrative, others included the use of iconographic symbols, and a few portrayed gruesomely detailed scenes. The way the artist chose to render the story was not merely based on their interpretation of biblical events. Often, the content of an image was mandated by contracts set by the artist's patrons. In other cases the artist was influenced by the function of the images and where they would be located. For example, religious scenes that were geared for the inner sanctum of a monastery might have been more graphic than those created for the main sanctuary of a church, in order to highlight the suffering of Christ and thereby inform prayer and study.

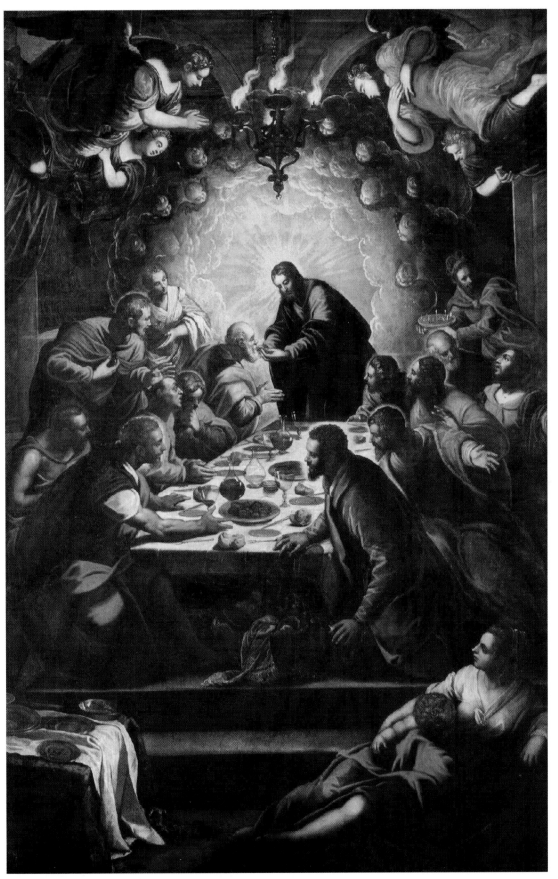

JACOPO ROBUSTI TINTORETTO, *The Last Supper (1592). In this depiction of the Last Supper, Tintoretto uses the foreshortening device of extending the table into the painting. Jesus is at the visual center of the painting, standing and serving the bread (a symbol of his body) to one of the disciples. This is unlike the actual scriptural story, which makes no reference to Jesus feeding each disciple. This image turns the Last Supper into a representation of the sacrament of communion. Jesus' divinity is emphasized not only by his halo, but also by the radiant clouds that open behind him like a portal into heaven. His sacrifice serves as the catalyst for the gates of heaven to be reopened to humanity.*

On the first day of Unleavened Bread the disciples came to Jesus, saying, "Where do you want us to make the preparations for you to eat the Passover?" He said, "Go into the city to a certain man, and say to him, 'The Teacher says, My time is near; I will keep the Passover at your house with my disciples.'" So the disciples did as Jesus had directed them, and they prepared the Passover meal. When it was evening, he took his place with the twelve; and while they were eating, he said, "Truly I tell you, one of you will betray me." And they became greatly distressed and began to say to him one after another, "Surely not I, Lord?" He answered, "The one who has dipped his hand into the bowl with me will betray me. The Son of Man goes as it is written of him, but woe to that one by whom the Son of Man is betrayed! It would have been better for that one not to have been born." Judas, who betrayed him, said, "Surely not I, Rabbi?" He replied, "You have said so."

While they were eating, Jesus took a loaf of bread, and after blessing it he broke it, gave it to the disciples, and said, "Take, eat; this is my body." Then he took a cup, and after giving thanks he gave it to them, saying, "Drink from it, all of you; for this is my blood of the covenant, which is poured out for many for the forgiveness of sins. I tell you, I will never again drink of this fruit of the vine until that day when I drink it new with you in my Father's kingdom." When they had sung the hymn, they went out to the Mount of Olives.

Matthew 26:17–30

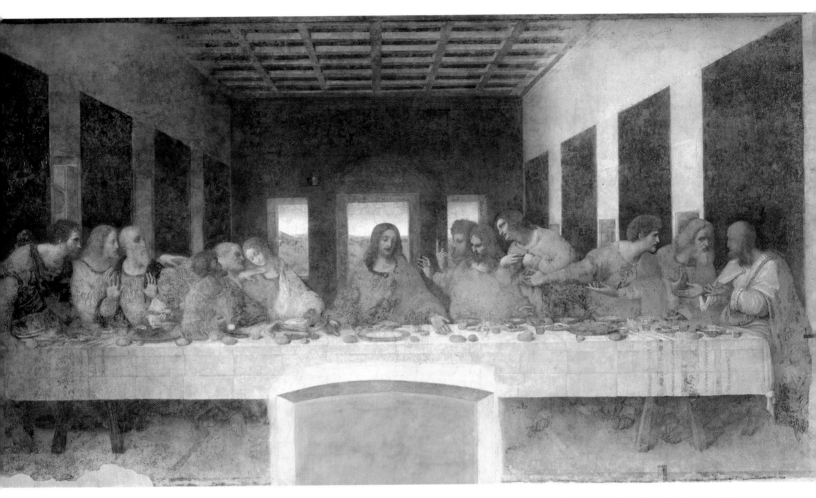

LEONARDO DA VINCI, The Last Supper (1494–98). Da Vinci's The Last Supper is placed at the far end of the refectory (dining hall) in Santa Maria delle Grazie in Milan. The meaning behind the location of this painting is unmistakable. The monks who dined before this image would be able to witness and join in the symbolic meal taking place, now known as the Eucharist. While taking in nourishment for their bodies, the monks could contemplate the betrayal that Christ had just revealed to his disciples and the metaphor of his sacrifice, presented through the Last Supper's communion. With outstretched arms, Christ offers the spiritual nourishment of his body and blood in the form of bread and wine.

A Pivotal Meal

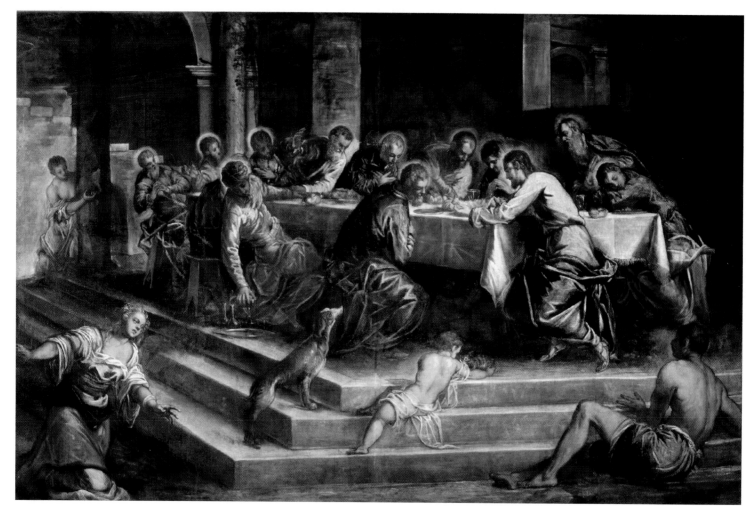

JACOPO ROBUSTI TINTORETTO, The Last Supper (1575–80). The Passover seder shared by Jesus and his apostles occurred at the house of Simon. In other images of the Last Supper only thirteen figures are present— Jesus and his twelve companions. Here, Tintoretto includes four other figures who are perhaps ready to clear the table, as it appears the meal is over. Jesus and Peter are in deep conversation, with the other apostles listening in or talking amongst themselves. Also present in the scene is a hound, placed near Judas. In sacred Renaissance art, the placement of a dog with or near Judas refers to his impending betrayal and the fact that Satan had entered Judas. (Hounds or dogs in secular art are an indication of fidelity, but they have the opposite meaning in sacred art.) Judas, at Peter's left, is completely unengaged with the others and reaches for something concealed beneath the table, perhaps in preparation to leave.

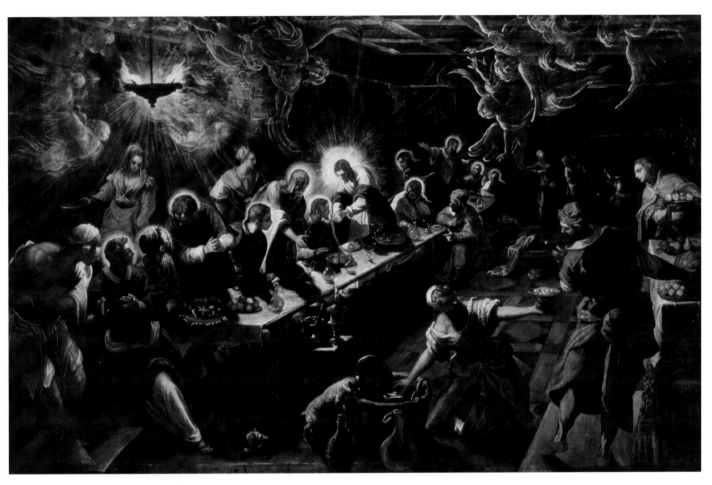

JACOPO ROBUSTI TINTORETTO, The Last Supper, *(ca. 1560). A scene usually set in a humble version of Simon's house, this version of* The Last Supper, *painted by Tintoretto for the church of San Giorgio Maggiore in Venice, is a dynamic display of activity. Instead of a horizontal scheme, the long table is at an angle that deeply penetrates the space of the painting. Christ is identified by his bright halo, or aureole, and the other disciples, except Judas, are identified by smaller ones. Judas, dressed in red—a color attributed to him and the blood he causes to be shed—is placed on the opposite side of the table. His position and lack of halo signify his status as having fallen from grace. Preoccupied with the activities of serving the meal, the other incidental figures in the scene observe, yet seem unaware of, the meaning of this specific seder. In a display of genius, Tintoretto delicately places ghostly apparitions of angels, who seem to manifest from the flames and smoke of the lantern, further signifying the importance and holiness of the event and the change it will elicit.*

A Pivotal Meal

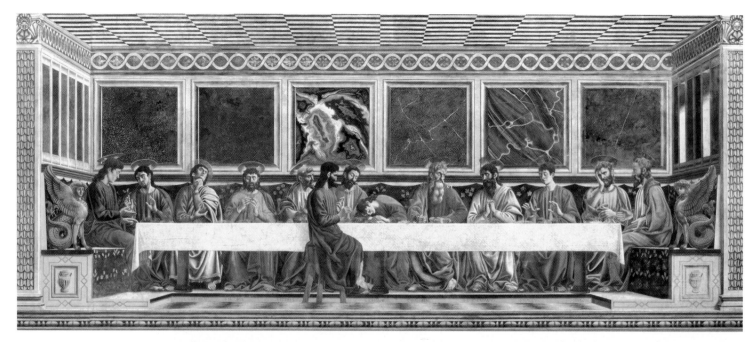

ANDREA DEL CASTAGNO, The Last Supper *(1445). Andrea del Castagno's fresco of the Last Supper exhibits the Renaissance artist's quest for expressing and depicting the harmony of the natural world. The setting is an imagined ancient Roman interior, complete with sculptures of griffins placed at the ends of the long bench and sumptuous decorations of marble-inlaid walls, Corinthian pilasters, and a coffered ceiling. The apostles are seated along the long, horizontal table, and Jesus sits sideways so we can see him completely.*

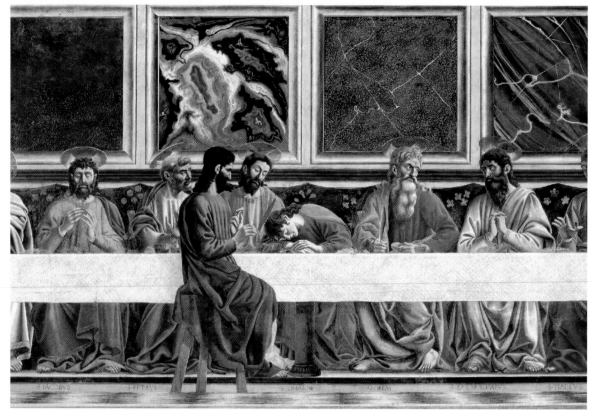

In this detail of The Last Supper, *we see that Andrea del Castagno has painted the figures as variations of Semitic archetypes, reinforcing that these men (including Jesus) were Jews. Rather than being seated in an elegant chair, Jesus sits on a humble wooden stool, an allusion to the cross. The design of the marble panel placed behind Jesus cannot be ignored. Unlike the other marble panels depicted, it has a fiery appearance. Fire has long signified change and purification of the spirit, and the placement of this specific marble panel near Jesus' head suggests that his sacrifice will elicit both, along with the ushering in of the New Testament.*

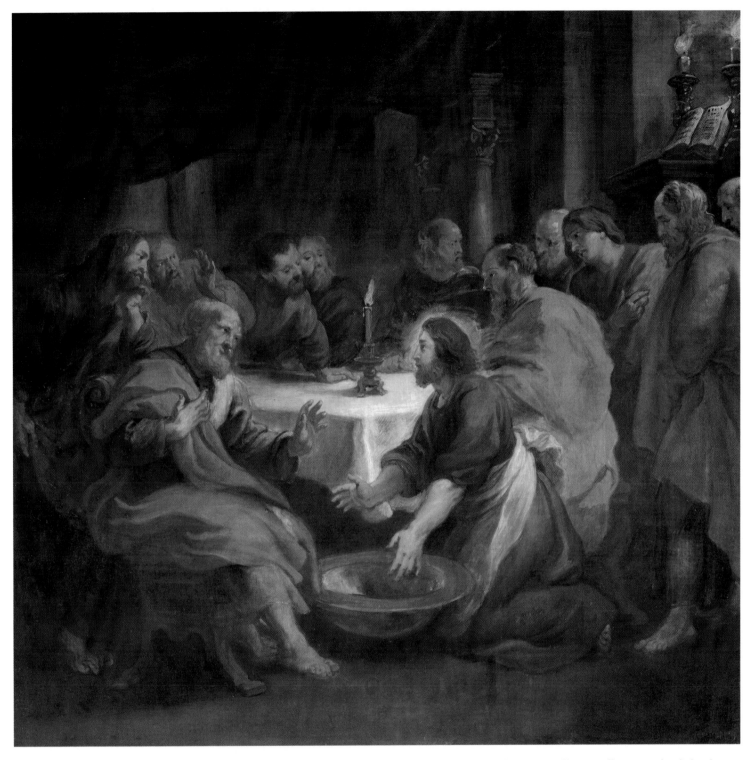

PETER PAUL RUBENS, Christ Washing the Apostles' Feet (1632). *Set in a small room, illuminated only by the light of three candles and a limited amount of natural light from the window, this scene shows Christ preparing to wash the apostles' feet. Peter is objecting to Jesus' gesture of humility, but we can see Jesus explaining his actions and motive. Centrally placed and kneeling, he is captured in this painting like a snapshot captures a candid moment. Identified not only by his position but also by his halo, Christ is portrayed by Rubens as a heroic, monumental figure. John the Evangelist stands to the far right, and an open Bible is placed between two candles on the ledge above and behind him.*

And during supper Jesus, knowing that the Father had given all things into his hands, and that he had come from God and was going to God, got up from the table, took off his outer robe, and tied a towel around himself. Then he poured water into a basin and began to wash the disciples' feet and to wipe them with the towel that was tied around him. He came to Simon Peter, who said to him, "Lord, are you going to wash my feet?" Jesus answered, "You do not know now what I am doing, but later you will understand." Peter said to him, "You will never wash my feet." Jesus answered, "Unless I wash you, you have no share with me." Simon Peter said to him, "Lord, not my feet only but also my hands and my head!"

John 13:2–9

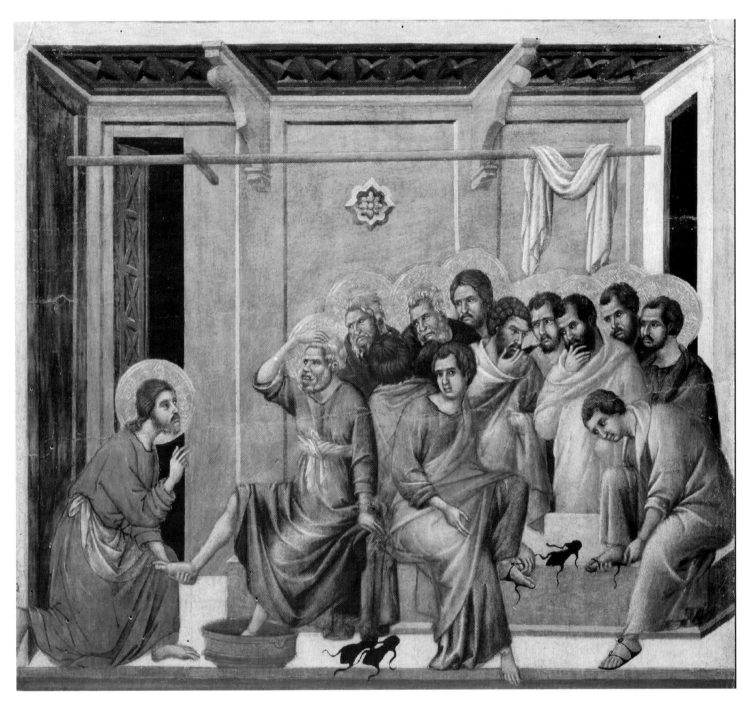

DUCCIO, Christ Washing the Disciples' Feet *(1308–11). This early Renaissance work is a panel from the Maestá Altarpiece. At the left of the tiny room, kneeling before his disciples, Jesus starts to wash Peter's feet in a basin. In this depiction, a sense of modesty is maintained, as Jesus is completely clothed. Peter and Jesus are conversing, indicated by their gestures. Peter, obviously confused about Jesus' actions and protesting, scratches his head. The other disciples present are also perplexed, as they scratch their beards and observe Jesus' actions with varying states of confused expressions. Judas is the only disciple whose face we do not see. Rather than facing out like the others, he is turned away.*

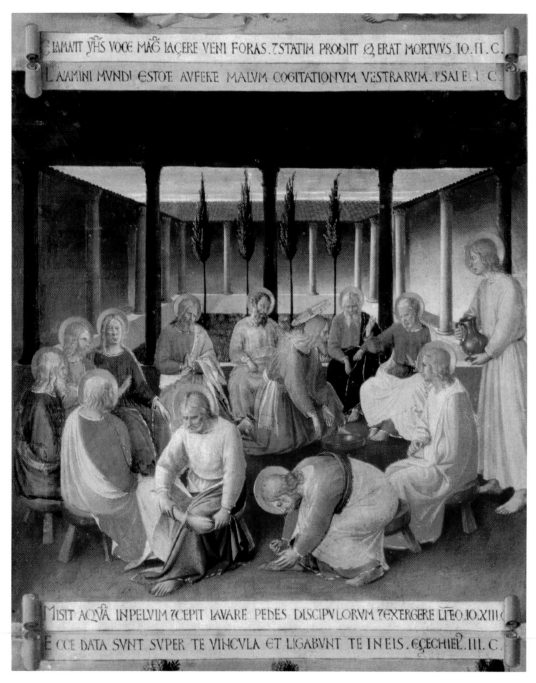

FRA ANGELICO (1387–1455), *Christ Washing the Feet of the Apostles. Fra Angelico, a Dominican friar, painted this image for the Silver Cabinet in the convent of SS. Anunzziata. The scene is depicted with captions written in Latin along scrolls that further enhance the scriptural story. Set in a loggia with a courtyard behind it, in an area similar to those found within the confines of a monastery or abbey, Jesus washes the feet of the apostles. Jesus is in the center of the group, kneeling before Peter, preparing to wash his feet. According to scripture, he stripped off his garments (except for his loin coverings) and used his clothing to do the washing. But, keeping Jesus clothed, Fra Angelico departs from the scriptural account, perhaps out of a sense of clerical modesty, as nudity was considered to be a symbol of the fall of Adam and Eve.*

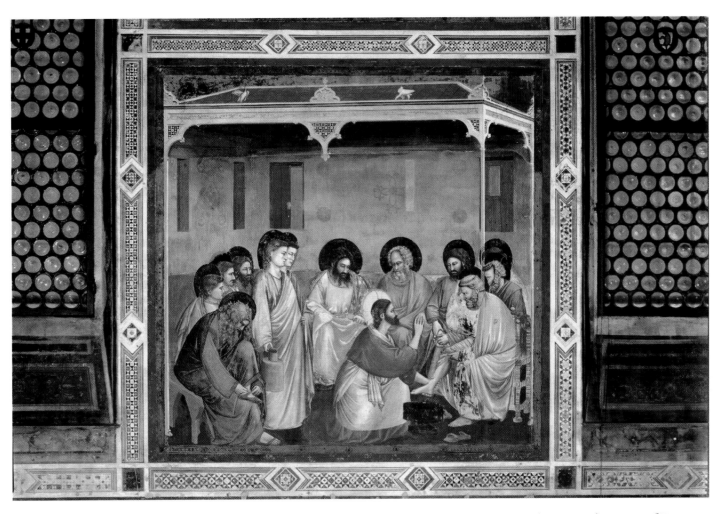

GIOTTO DI BONDONE, Christ Washing the Feet of the Disciples *(1301–13). In many depictions of Jesus washing his disciples' feet, Judas is left out of the scene, an open door signifying his recent exit and pending betrayal of Christ. Giotto's version for the Scrovegni Chapel in Padua is no exception. Considered to be one of the first official Renaissance masters because of his understanding of perspective, Giotto places Christ in the center of the painting, surrounded by his disciples. A master of fresco, Giotto expresses with great skill the fluidity of fabric and human movement.*

Before the Cock Crows Twice

CHRIST'S BETRAYAL AND ARREST

Herod, the high priest Caiaphas, and the elders are trying to figure out how to secretly get rid of Jesus when Judas, one of Jesus' disciples, offers them the solution. Just before Passover, Judas, struck with greed and possessed by the devil, makes a deal with Caiaphas and his cohorts to deliver Jesus to them in exchange for thirty pieces of silver.

But Judas is not the only disciple guilty of betrayal. After the Last Supper, Jesus tells Peter, one of his closest disciples, "Truly I tell you, this day, this very night, before the cock crows twice, you will deny me three times" (Mark 14:30). In response, Peter swears his undying fidelity, but Jesus' prediction will later come true.

Jesus goes to the Garden of Gethsemane (in the Mount of Olives) to pray and prepare for what lies ahead of him. Peter, along with James and John, follows him. Jesus asks his companions to sit with him as he prays. Yet, at Jesus' hour of need, the disciples fall asleep again and again. While Jesus prays for guidance and strength, releasing himself to do God's will and deal with the task ahead of him, an angel appears before him, giving him strength. In his agony, Jesus prays so hard that his sweat becomes like drops of blood—an event that Renaissance and Baroque artists used to heighten the emotional quality of the scene and of Jesus' humanity. For at this moment, he is probably his most human. The agony that Jesus suffers in the garden is not only from his own sorrow and fear, but also because his disciples failed him by falling asleep when they were supposed to be tending to and protecting him.

After the third time Jesus finds the disciples sleeping, he sees Judas and an entourage of high officials, soldiers, and the curious approaching. Betrayed by Judas with a kiss, Jesus is taken into the custody of the soldiers. Although the kiss is considered the "official" betrayal, a second one occurs when his disciples scatter in fear, except for Peter, who remains with him. As Jesus is arrested, an angry Peter draws his sword and slices off the right ear of Malchus, Caiaphas's servant. But, in a turn of events that must have seemed bizarre to the bloodthirsty Romans, a resigned, peaceful Jesus admonishes Peter to put away his sword, then touches Malchus's ear and heals him. Thus, Jesus shows to all who witness this act that he is divine, only furthering the case against him. For the soldiers still bind him and carry him off.

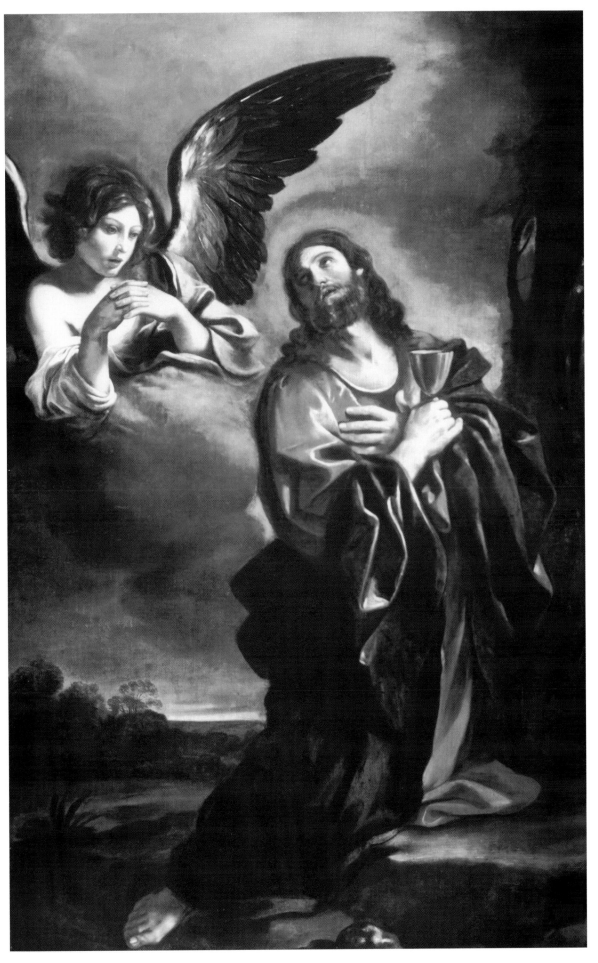

GUERCINO, Christ in Gethsemane *(ca. 1620). Guercino's* Christ in Gethsemane *is set at dusk, and the focus is on the praying Christ. Removed from the disciples, humble and elegant, Jesus engages in a sacred conversation with the angel who has come to him. Jesus holds a chalice, perhaps in reference to his plea for God to "remove this cup from me" (Mark 14:36). It also foreshadows the cup that will catch the blood that drips from his pierced side after he dies on the cross, and it is a reminder of the meaning of his sacrifice.*

21

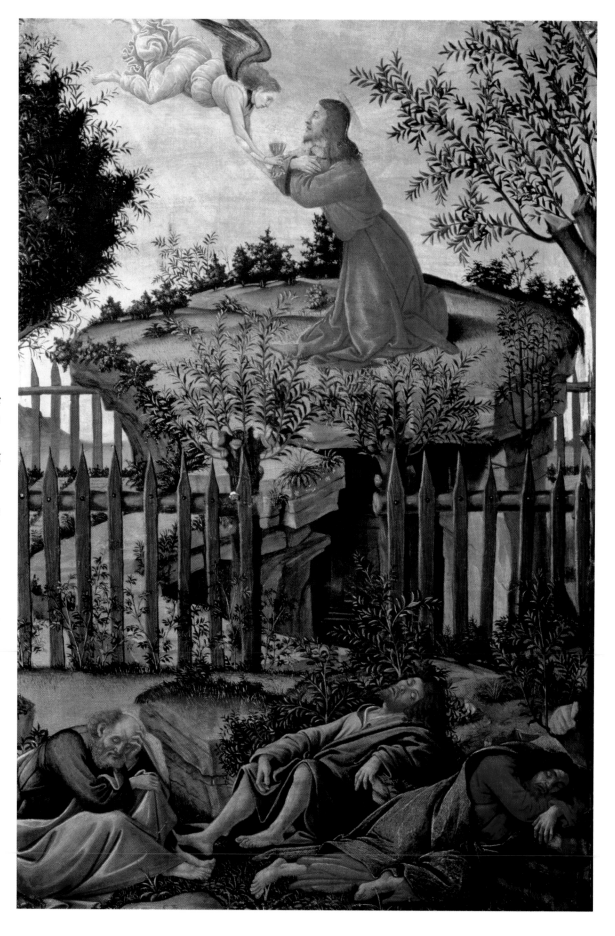

SANDRO BOTTICELLI, Christ in the Garden of Olives *(1497–98). Botticelli sets the scene of* Christ in the Garden of Olives *in a double-enclosed garden. The pious Jesus, in the reverie of prayer, is visited by an angel who presents him with a cup and a floating wafer of unleavened bread—the instruments of the Eucharist. Jesus is separated from the sleeping apostles by a wooden gate, which symbolizes the entrance to heaven, reopened to humanity through Jesus' sacrifice. The cave beneath the platform upon which Jesus prays foreshadows the holy sepulcher (burial tomb) and Jesus' eventual resurrection. The olive trees and their fruit, the olive, have traditionally represented offerings of peace. Here, they are symbols of the peace that God is making with humankind through the sacrifice of his son.*

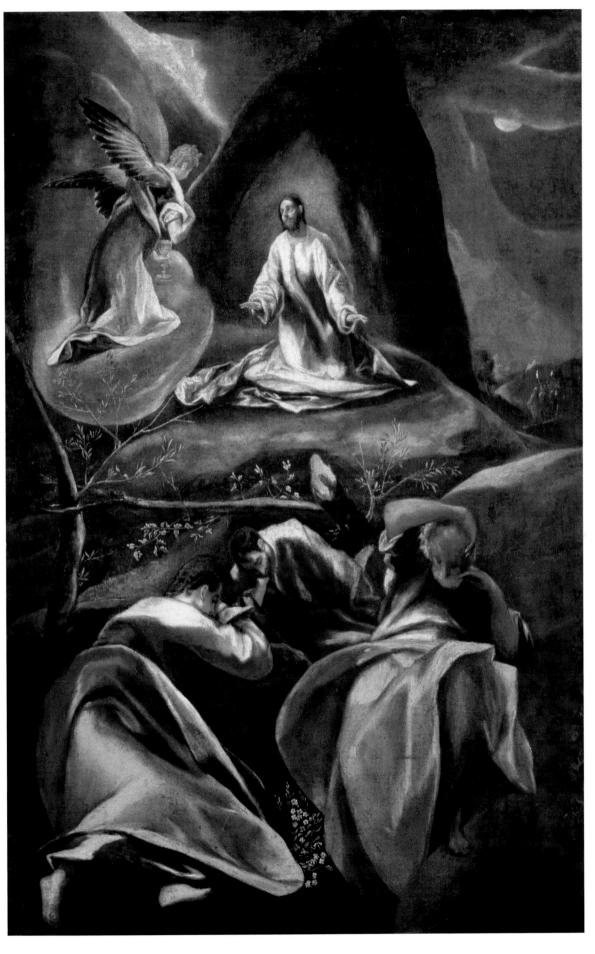

DOMENICO THETOCOPULI, CALLED EL GRECO, Christ in the Garden of Olives (ca. 1580). El Greco's mysterious, thin figures lend an element of hyper-imposed spirituality to the scene. The full moon rises and is partially eclipsed by the looming clouds, signifying approaching doom. A spiritual man, El Greco is careful to be accurate in presenting the real-life aspects of the Passion, as the Jewish calendar follows the lunar cycle, and Passover occurs at full moon. The hovering angel presents Jesus with the chalice, the often-used emblematic device that symbolizes the sacrament. The activity of the heavenly figure and the praying Jesus is placed in contrast to the sleeping apostles. In the distance, torches and indistinct figures are barely identifiable. El Greco's focus is not on the betrayal, but on divinity and salvation.

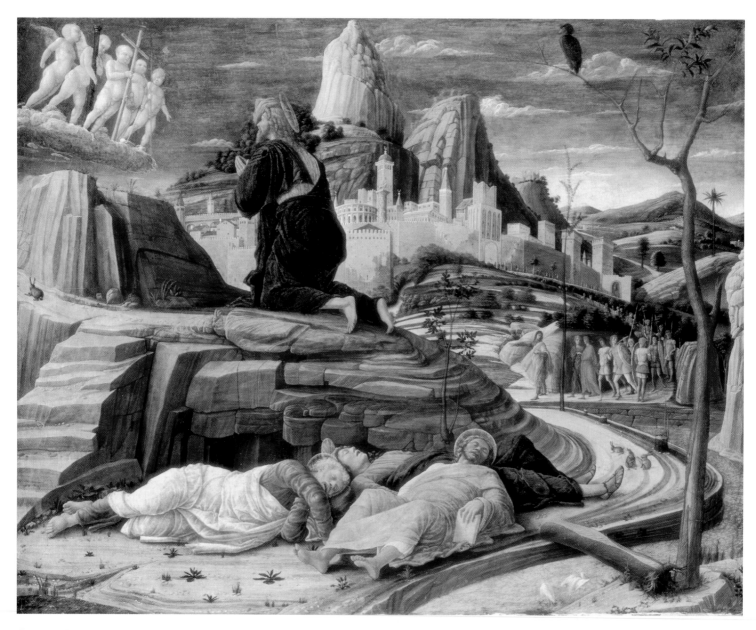

ANDREA MANTEGNA, *Agony in the Garden (ca. 1460). The setting of this painting is a combination of the landscapes of an imagined Jerusalem and actual fifteenth-century Tuscany. Mantegna uses many iconographic devices and allusions to the entire story of the Passion. The scene is set on the Mount of Olives, yet in a non-gardenlike location. The apostles, one of whom holds a Bible, sleep near the Brook Cedron. Jesus prays at an altarlike outcropping of rocks, above which five cherubs hover. The central one bears a cross, and the two on either side of him are holding a staff and a scepter, respectively. Together, these are instruments of the Passion and of Jesus' role as shepherd and savior. Off in the distance, Judas leads the soldiers to make their arrest. Behind Jesus, on the tree, is a black buzzard, an omen that foreshadows his coming death. The scattering hares in the scene represent the people who put hope in Christ's salvation of humankind.*

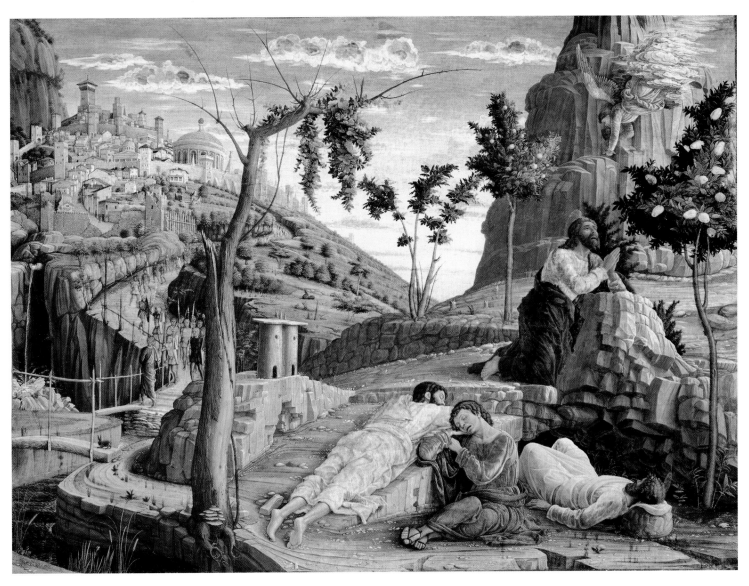

ANDREA MANTEGNA, The Garden of Gethsemane (ca. 1470). As in Mantegna's other work of the same subject, iconographic devices are used to enhance the story. Again, Jesus prays at an altarlike structure of rocks, below which seems to be a cave. This is a reference to his burial in a tomb. On either side of Jesus are two trees, an apple tree to the left and a pear tree to the right. The apple tree behind him represents the fruit eaten by Adam and Eve that led to the fall of humanity. The pear, as the anti-apple and a symbol of Christ's love for humankind, is placed in front of Jesus, through whom salvation from the fall can be found. Jesus, as the Christ, is the antithesis to Adam.

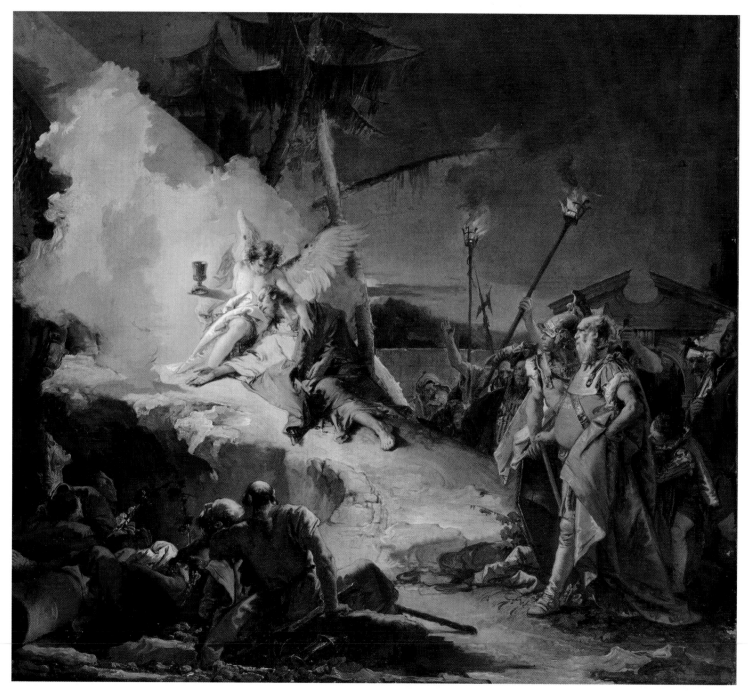

GIAMBATTISTA TIEPOLO, Christ in the Garden of Gethsemane *(1750). Tiepolo's narrative painting of* Christ in the Garden of Gethsemane *presents three key elements at once. Set apart from the three sleeping disciples, who are placed in the dark foreground, Jesus is farther up the hill, illuminated by his own spiritual light and by that of the heaven-sent angel. The angel, who has come to Jesus during his prayers, consoles him, reassuring him of the nature of his mission and presenting him with the chalice that is symbolic of the Eucharist. Meanwhile, the Roman soldiers, led by the betraying Judas, close in on Jesus, ready to make their arrest.*

o Judas brought a detachment of soldiers together with police from the chief priests and the Pharisees, and they came there with lanterns and torches and weapons.

John 18:3

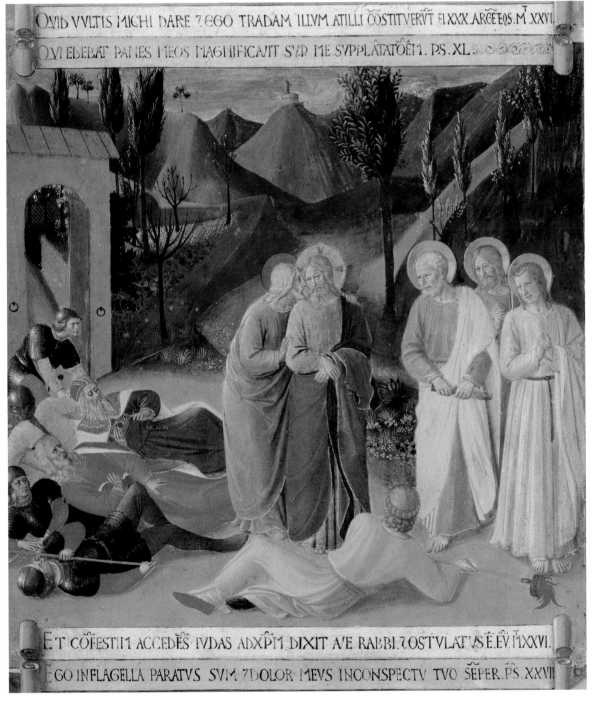

OVID VVLTIS MICHI DARE ? EGO TRADAM ILLVM ATILLI COSTITVERVT EI XXX ARGEEOS. M.XXVI.

OVI EDEBAT PANES MEOS MAGNIFICAVIT SVP ME SVPPLATATOEM . PS .XL

ET COFESTIM ACCEDES IVDAS ADXPM DIXIT AVE RABBI. OSTVLATVS E. EV. MXXVI.

EGO IN FLAGELLA PARATVS SVM 7 DOLOR MEVS INCONSPECTV TVO SEPER. PS. XXVII

FRA ANGELICO, The Kiss of Judas *from* Scenes from the Life of Christ *(1437–45). Painted for the monastery of San Marco, this image was to be a daily reminder of the acts of Christ. The scene is set within a gated garden, signifying the entrance to heaven that will be opened through Jesus' sacrifice and resurrection. Here, the betraying kiss is emphasized. The other activity in the scene is unusual, as the soldiers seem to rouse the sleeping disciples at the left, while at the right, three other holy figures observe. Some of the soldiers at the left lay prostrate on the ground, thus creating an image of Christ's eventual triumph over tyranny and spiritual death. Unlike in other portrayals of Judas, Fra Angelico gives him a halo, although a slightly tarnished one, as if to suggest that he was not acting out of his own free will but as an agent of the devil.*

"See, the hour is at hand, and the Son of Man is betrayed into the hands of sinners. Get up, let us be going. See, my betrayer is at hand." While he was still speaking, Judas, one of the twelve, arrived; with him was a large crowd with swords and clubs, from the chief priests and the elders of the people. Now the betrayer had given them a sign, saying, "The one I will kiss is the man; arrest him." At once he came up to Jesus and said, "Greetings, Rabbi!" and kissed him. Jesus said to him, "Friend, do what you are here to do." Then they came and laid hands on Jesus and arrested him.

Matthew 26:45–50

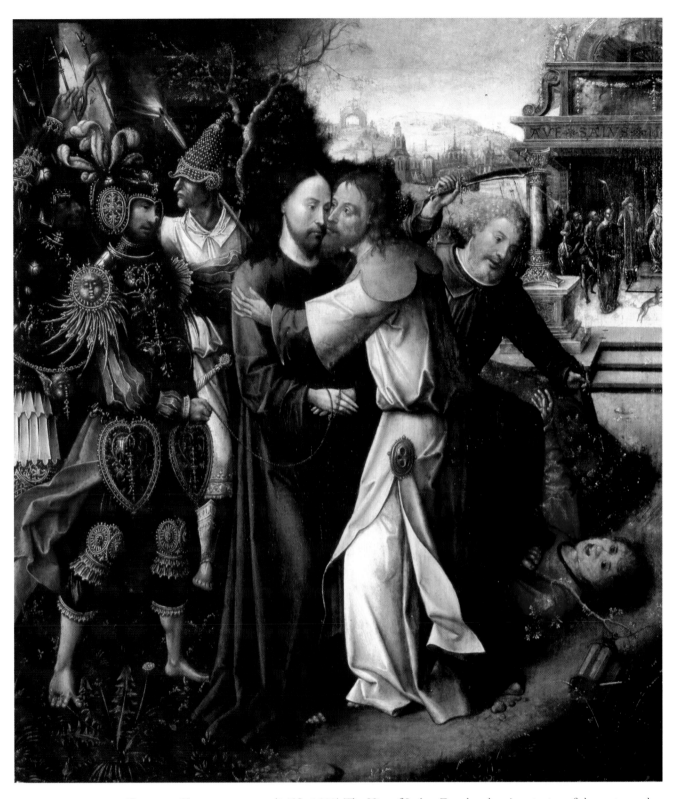

CORNELIS ENGEBRECHTSZ (1468–1533), The Kiss of Judas. *Engebrechtsz's painting of the scriptural account is an example of a northern Renaissance interpretation. Within the confines of a small space, Engebrechtsz presents a lot of activity throughout the image. Directly in the foreground, Judas, with his money sack clipped to his hip, embraces Jesus while shaking his hand in an odd juxtaposition of gestures. Behind the central figures is the multitude of soldiers, clad in sumptuous fabric and gilt armor. To the right, and slightly behind the central pair, Peter has knocked the servant Malchus to the ground and, with his arm and sword raised, is ready to sever the servant's right ear.*

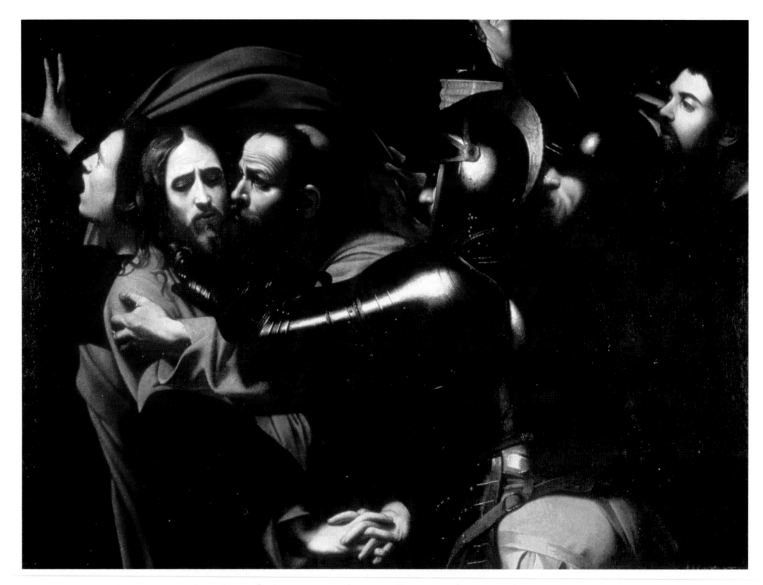

MICHELANGELO CARAVAGGIO, The Taking of Christ *(1602). This compelling scene focuses on the moment the kiss of betrayal is delivered, emphasized by the red cloth above the heads of Jesus and Judas. As Judas moves in to embrace Jesus, a soldier stretches across the pair to seize Jesus by the cloak, reaching near his throat. Evident is the contrast between the aggressive motion of this soldier and the piety of Jesus, who, with downcast eyes, a furrowed brow, and folded hands, accepts his fate.*

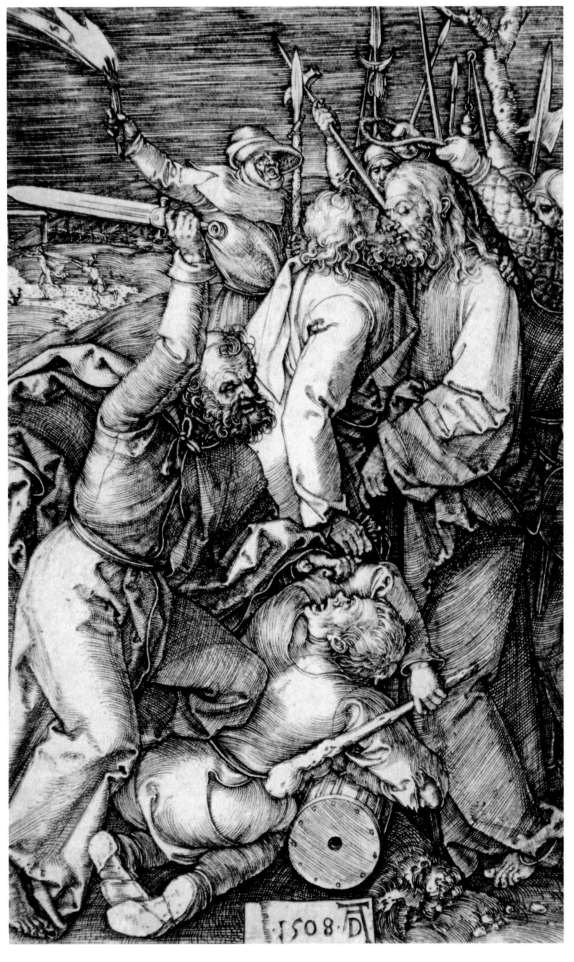

ALBRECHT DÜRER, Betrayal of Christ *(1508)*. *In this work from the Engraved Passion series, we see an active, tumultuous scene that is as narrative and dynamic as a painting. The movement of the soldiers and their weapons—torches and tethers, along with Peter's aggression—is placed around the central characters. The anger associated with the activity of all these figures is juxtaposed with the apparent gentility of the kiss of betrayal delivered to Jesus by Judas. The way this mock gentility is presented by Dürer heightens the tragedy and the sinister nature of the betrayal itself. Even with the limited palette of an engraving, Dürer expresses the charged emotions of the scene. The soldier placing the tether upon Jesus does so in a manner that casts it as a halo, further signifying Jesus' holiness and separation from the evil and sinful nature of humankind.*

hen one of the twelve, who was called Judas Iscariot, went to the chief priests and said, "What will you give me if I betray him to you?" They paid him thirty pieces of silver. And from that moment he began to look for an opportunity to betray him. . . . When Judas, his betrayer, saw that Jesus was condemned, he repented and brought back the thirty pieces of silver to the chief priests and the elders. He said, "I have sinned by betraying innocent blood." But they said, "What is that to us? See to it yourself." Throwing down the pieces of silver in the temple, he departed; and he went and hanged himself.

Matthew 26:14–16; 27:3–5

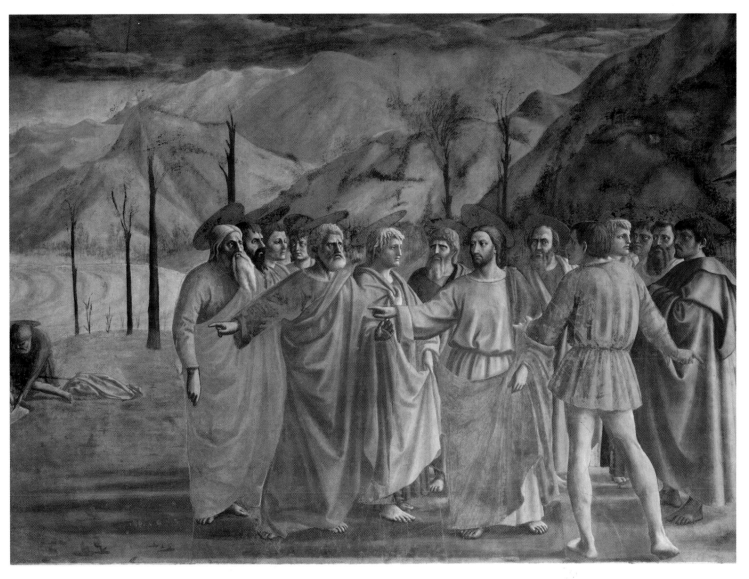

MASACCIO, The Tribute Money (ca. 1425). Here, Jesus tells Peter and the disciples that Peter should cast a line into the sea, and that the first fish he catches will have in its mouth a silver piece that is enough to pay all of their taxes (an event that predates the Passion). Masaccio places Judas with his back to the viewer and as the only disciple set apart from the others. Alienated from them, this placement prefigures Judas as the one who, using money as an agent, will later betray Jesus. Judas can also be easily identified in works of art by his sack of money and his unattractive features that suggest an ugliness of heart and soul that can be read upon his face. Since the Passion, the name Judas has been associated with traitors of the worst kind.

Before the Cock Crows Twice

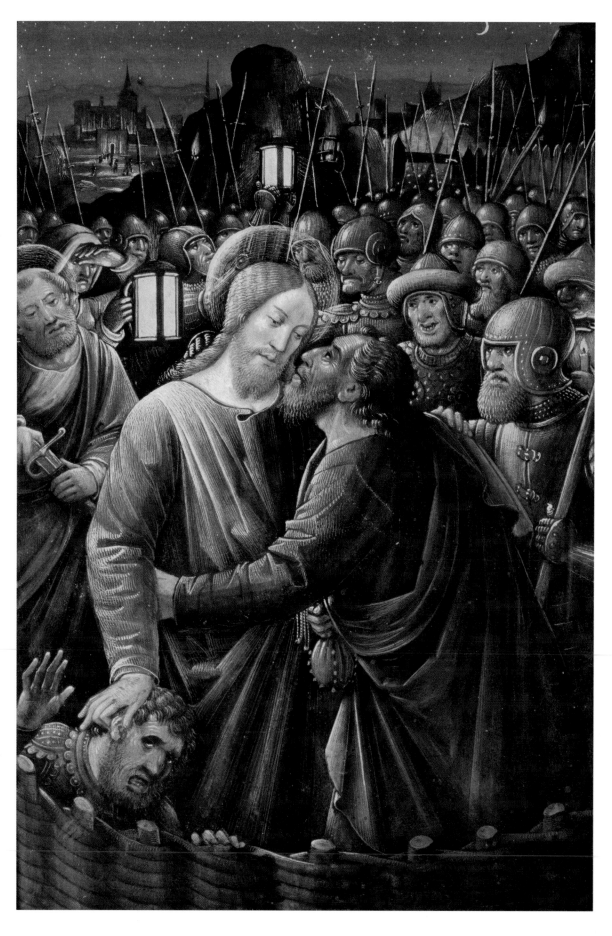

JEAN BOURDICHON, The Kiss of Judas *(ca. 1500).* *This French image of Judas's betrayal was painted in rich colors on vellum for a book of hours, an illuminated manuscript of daily prayers for the wealthy. Unlike an Italian version of the scene, the figures here are neither classical nor heroic. Bourdichon strays from the actual details of the event, painting a night sky at new moon rather than at the full moon, the time of the Passover feast. Despite its discrepancies from scripture and other Renaissance works, the scene is nonetheless active and compelling. Judas's betrayal of Jesus occurs at the front and center of the image. Jesus is presented as a beautiful, pious figure with soft features; the angry mob of soldiers and spectators are ugly, rough, bloodthirsty characters. Jesus' compassion and divinity at this horrid moment are further emphasized by his miraculous healing of the ear of the servant who had just been maimed by Peter. A repentant, chastened Peter resheathes his sword following Jesus' condemnation of his angry assault.*

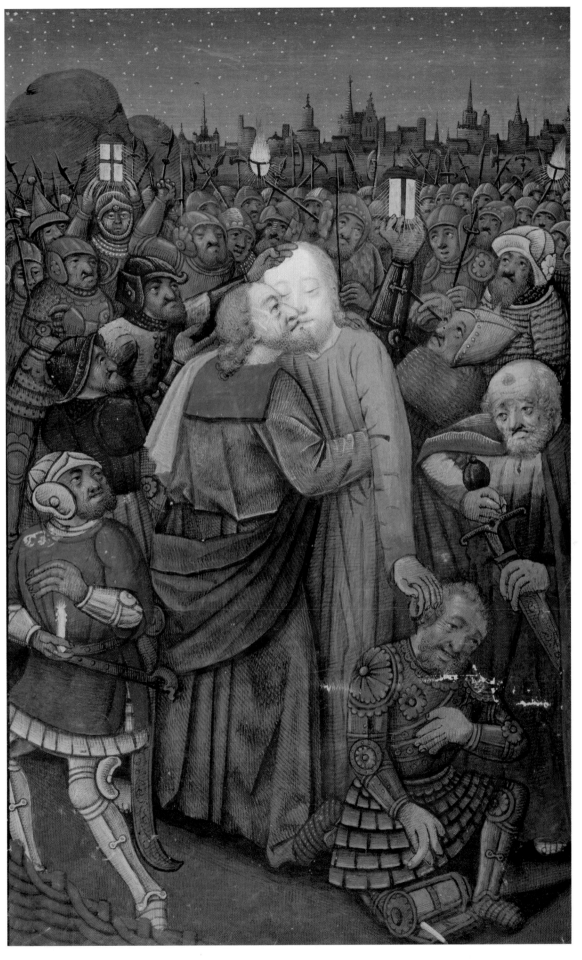

CIRCLE OF THE COETIVY MASTER, The Kiss of Judas (1460). This image is an illustration for the fifteenth-century illuminated manuscript Heures de Marguerite de Coetivy. The page opposite the image would have had the scripture associated with the illustration. This scene was most likely selected for the book because of the moral lesson of Jesus admonishing Peter's passionate yet apparently justified behavior of attacking one of Jesus' arresters. Instead of a bloody scene, we see Peter returning his sword to its sheath while Jesus performs the miracle of healing Peter's victim. For Jesus, Peter's violence was unwarranted, against God's will, and in opposition to his teaching to "turn the other cheek."

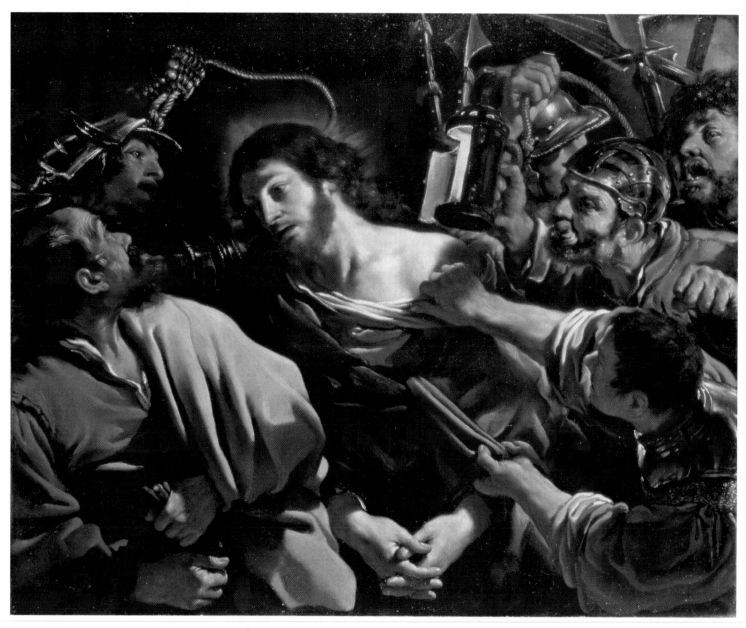

GUERCINO, The Betrayal *(1621). Guercino's* The Betrayal *is an emotionally powerful image that expresses both Jesus' piety and his disappointment in Judas. Rather than showing the actual kiss of the betrayal or Peter's reaction to Jesus' arrest, the artist chose to focus on the unspoken words expressed in the gazes of the central characters. With strong chiaroscuro (use of light and dark), Jesus seems to be illuminated from within, his skin almost glowing, while the other figures in the scene are cast in darkness and shadow. The soldiers grab at Jesus, pulling his clothing, while a fearful, guilty Judas shrinks back from Jesus. Clutching his sack of money, Judas moves farther into the darkness, away from the light radiating from Jesus.*

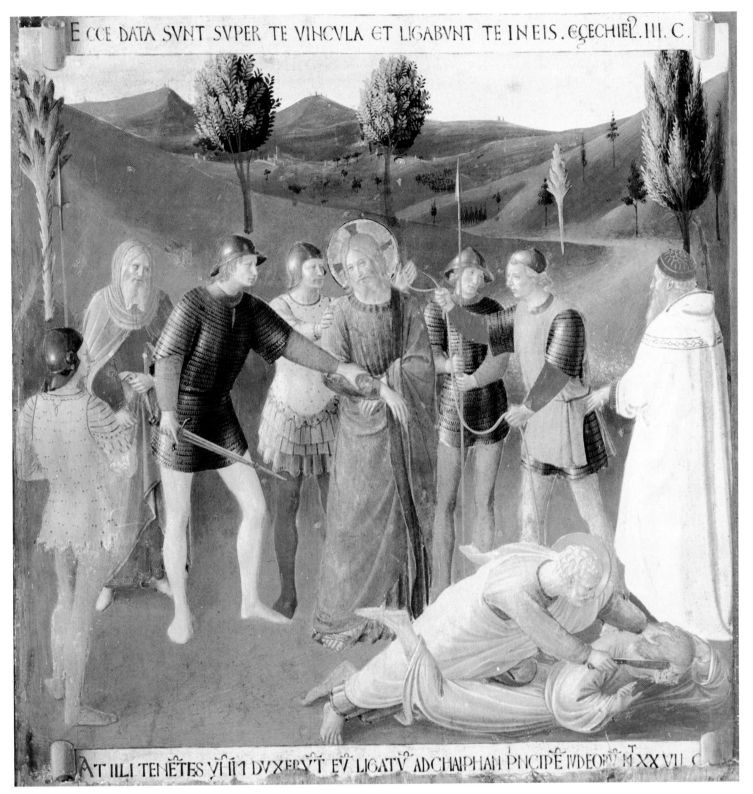

ECCE DATA SVNT SVPER TE VINCVLA ET LIGABVNT TE IN EIS. EÇECHIEL. III. C.

AT ILLI TENĒTES VĬ ĬĬ DVXERVT EV LIGATV ADCHAIPHAN PNCIPE IVDEOR XXVII C

FRA ANGELICO, The Capture of Christ (1450). In this image, there is a stark contrast between violence and peace. Five soldiers, a high priest, and Judas, who clutches his bounty fee, surround Jesus. Threatened with a sword and about to be bound, Jesus stands passive, accepting the fate of his arrest. In the foreground, Peter succumbs to his anger and knocks Caiaphas's servant to the ground with a knee in his back. Peter holds the servant's head, violently chopping off the right ear, depicted by Fra Angelico in graphic detail as blood pours from the severed ear, staining the ground. Placed between the activity of the unjust soldiers and what we might consider to be Peter's justified act, Jesus' posture and position are reminders that his teachings condemn both.

Ecce Homo: Behold the Man

CHRIST'S TRIAL AND SENTENCE

The soldiers take Jesus to the high court, where Caiaphas, the high priest, had assembled with the other priests, elders, and scribes. Some of the observers bear false witness against Jesus. But their testimonies against him do not match, and thus the council cannot find him guilty. Angered, Caiaphas asks Jesus directly if he is "the Son of the Blessed." Christ responds, "I am." Calling him blasphemous, Caiaphas sentences Jesus to death, yet not without delivering dreadful torture upon him. He rips off Jesus' clothing and allows the angry mob of viewers and soldiers to spit upon and beat him.

During his trial, Jesus suffers yet another betrayal—the one he had prophesied in the Garden of Gethsemane. Several people point out Peter as being one of Jesus' disciples, but before the evening is over, Peter denies Jesus three times.

The morning following the initial trial, Jesus is presented to Pontius Pilate, the governor, for final sentencing. Pilate cannot find any crime with Jesus. In an attempt to quiet the angry crowd, Pilate mentions the tradition of releasing a prisoner at Passover. He asks the crowd whether Jesus or Barabbas, a thief and murderer, should be released.

The crowd chooses Barabbas and condemns Jesus to crucifixion. Pilate realizes he has no choice: If there is to be *any* sort of civic peace, he must have Jesus crucified. A troubled Pilate literally washes his hands of the situation, declaring his own innocence of the matter and telling the crowd that Jesus' blood is upon all of them.

Jesus is released to the soldiers for further beating, scourging, and mocking. In an attempt to toy with the term "king," they make a crown of thorns and place it upon his head, then drape him in the royal color of purple. While there is no specific description of the actual beatings in the scriptural accounts, Renaissance and Baroque artists took great license with the subject, and their graphically bloody images of the flagellation served to heighten the cruelty of Jesus' detractors and simultaneously increase Jesus' spirituality. Such images were used to remind viewers of Christ's suffering for the sins of all people. Another image, the *Ecce Homo*, "Behold the Man" (with the implication of "here is the man that you have condemned") shows Christ delivered to the people by Pilate before the walk to Golgotha. It is at once a presentation of Jesus as a martyr and, for believers in him, a savior.

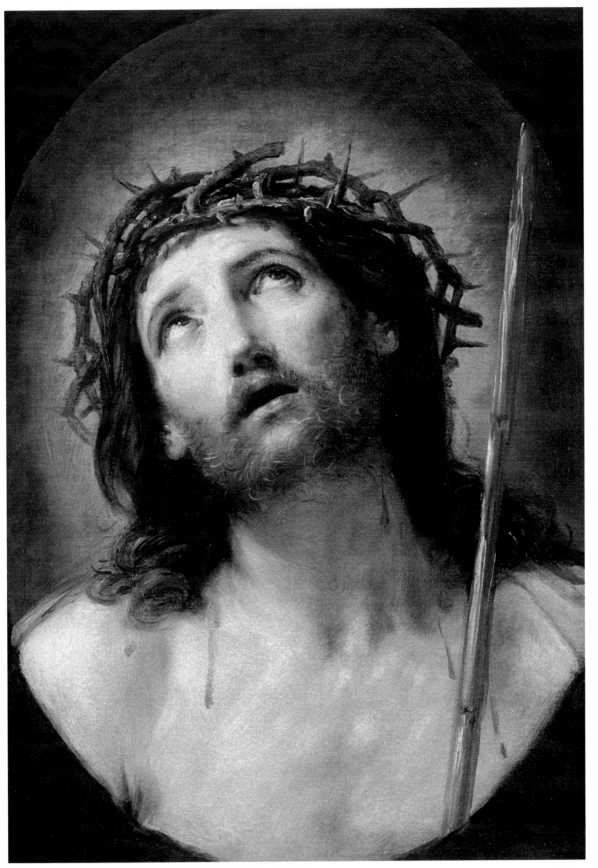

GUIDO RENI, Ecce Homo (ca. 1638). A portraitlike image of Jesus, Reni's Ecce Homo shows a tortured, sorrowful Christ. Iconlike, Christ is presented with the crown of thorns as he looks toward the heavens. His suffering and sacrifice are emphasized by the blood dripping from his brow, which shows his humanity. Christ holds a wood rod, evocative of both a shepherd's crook and a pilgrim's staff. Christ can be seen as the ultimate shepherd (of his flock of disciples and Christian followers) and the ultimate pilgrim, by his voyage through death to reopen the gates of heaven for humanity.

39

They took Jesus to the high priest; and all the chief priests, the elders, and the scribes were assembled.... Now the chief priests and the whole council were looking for testimony against Jesus to put him to death; but they found none. For many gave false testimony against him, and their testimony did not agree. Some stood up and gave false testimony against him, saying, "We heard him say, 'I will destroy this temple that is made with hands, and in three days I will build another, not made with hands.'" But even on this point their testimony did not agree. Then the high priest stood up before them and asked Jesus, "Have you no answer? What is it that they testify against you?" But he was silent and did not answer. Again the high priest asked him, "Are you the Messiah, the Son of the Blessed One?" Jesus said, "I am; and 'you will see the Son of Man seated at the right hand of the Power,' and 'coming with the clouds of heaven.'" Then the high priest tore his clothes and said, "Why do we still need witnesses? You have heard his blasphemy! What is your decision?" All of them condemned him as deserving death.

Mark 14:53, 55–64

GERRIT VAN HONTHORST, Christ Before the High Priest *(1617)* **(Opposite)**. *In a sinister, mysterious room illuminated by a single candle, Christ is presented before Caiaphas, who is seated at a table. The book before Caiaphas suggests an official document, perhaps a list of charges against Christ. The book also symbolizes the law—old and new, secular and religious, and the intersection thereof. An allusion is made to the Bible, to which Christ's death and resurrection will add a New Testament. Christ's divinity is expressed by his depiction as the most illuminated figure. Although the candle is closest to Caiaphas, Christ, considered "the light of the world," is the brightest figure. The people in the background, Jesus' detractors and false witnesses, are placed completely in the shadows, further emphasizing their evil nature.*

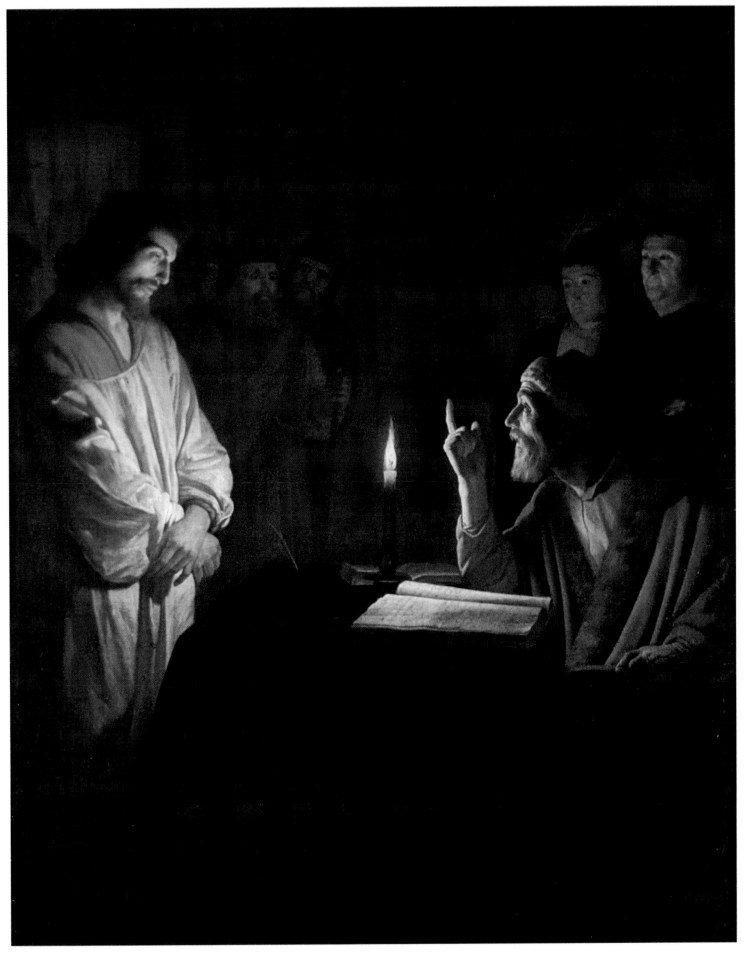

Ecce Homo: Behold the Man

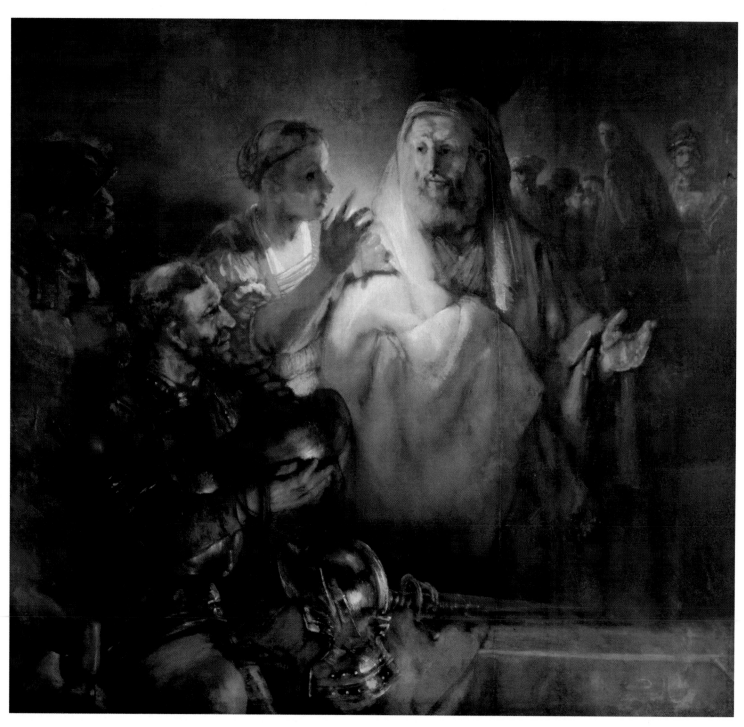

REMBRANDT HARMENSZ VAN RIJN, The Denial of St. Peter (1660). Before Jesus departs for the Garden of Gethsemane with three of his disciples, he tells Peter, "Before the cock crows, you will have denied me three times" (John 13:38). Rembrandt depicts the third and final denial, when Peter is approached by a relative of the servant whom he injured during Jesus' arrest. The waning light upon him represents his temporary slip. Peter's denial is another type of betrayal against Jesus, possibly even more emotionally profound than Judas's since Peter was one of the apostles closest to Jesus. But in the presence of Christ's oppressors, fear overtakes Peter in spite of his vow to die with Jesus. Peter's spirit is willing, but his flesh is weak.

Then they seized him and led him away, bringing him into the high priest's house. But Peter was following at a distance. When they had kindled a fire in the middle of the courtyard and sat down together, Peter sat among them. Then a servant-girl, seeing him in the firelight, stared at him and said, "This man also was with him." But he denied it, saying, "Woman, I do not know him." A little later someone else, on seeing him, said, "You also are one of them." But Peter said, "Man, I am not!" Then about an hour later still another kept insisting, "Surely this man also was with him; for he is a Galilean." But Peter said, "Man, I do not know what you are talking about!" At that moment, while he was still speaking, the cock crowed. The Lord turned and looked at Peter. Then Peter remembered the word of the Lord, how he had said to him, "Before the cock crows today, you will deny me three times." And he went out and wept bitterly.

Luke 22:54–62

Ecce Homo: Behold the Man

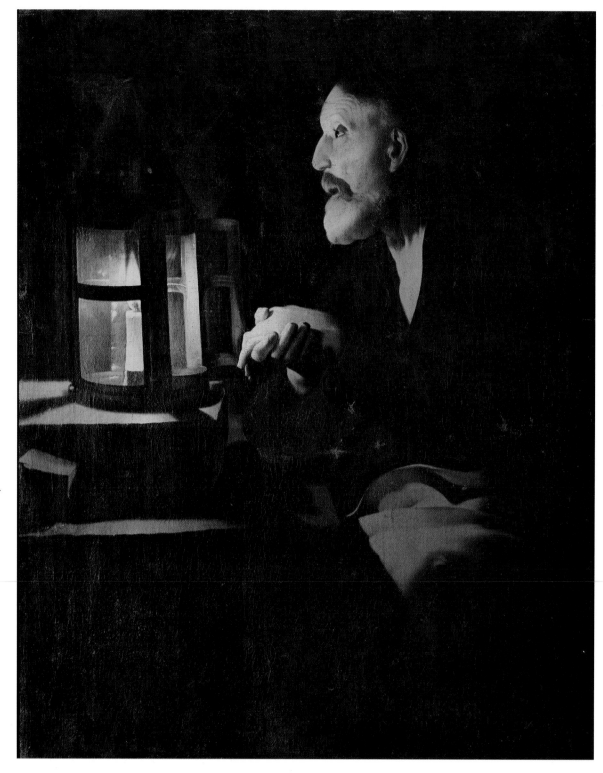

STUDIO OF GEORGE DE LA TOUR, The Tears of St. Peter (1646–48). A penitent Peter prays after realizing that Jesus' earlier declaration of his own betrayal came true. The use of chiaroscuro (depiction of light and dark), Peter's hands clasped in prayer, and the look on his troubled face all come together to depict the psychological interior of the character. Troubled, Peter prays for forgiveness as he sits alone with his guilt.

Then Pilate took Jesus and had him flogged.

John 19:1

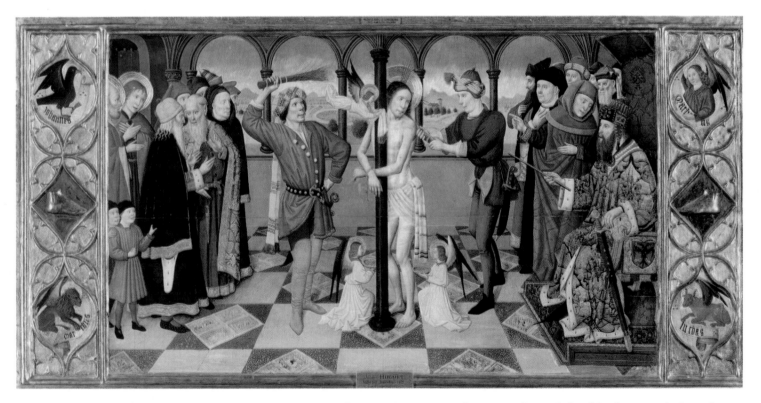

JAIME HUGUET, *The Flagellation of Christ (ca. 1450). In this image, the symbols of the four gospels (Matthew, Mark, Luke, and John) are placed at the corners of the framing device. Set in a classical interior courtyard, this scene shows a stripped Jesus tied to a column. To Jesus' left, Caiaphas is enthroned, with the false witnesses behind him. Across from Caiaphas are members of the council of high priests with two of the apostles behind them. The two angels at Jesus' feet look as if they are providing support, and the one flying near his head appears prepared to mop his brow.*

Ecce Homo: Behold the Man

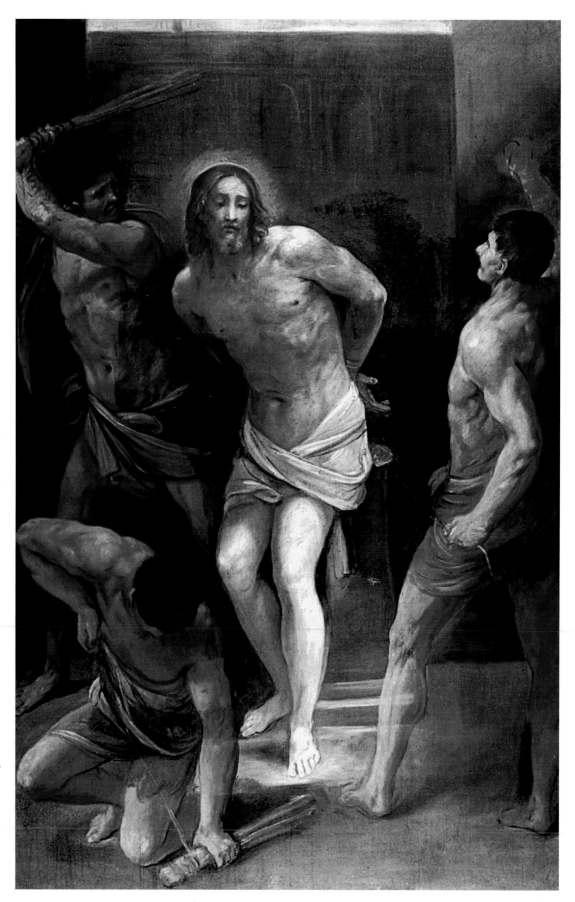

GUIDO RENI, Flagellation of Christ (1640–42). *Unlike Reni's* Ecce Homo, *this full-length action scene depicts the flagellation of Christ. All the figures in the scene have classically athletic bodies. Two of the figures beat Jesus, while the third (in the foreground) tightens his weapon, a bundle of reeds. Jesus' divinity and imminent death are emphasized by the presentation of his body in a chalky, yet glowing white tone, in contrast to the tanned bodies of his oppressors. An aureole of light not only emanates from Jesus' head, but is also cast upon the spot in which he stands, never intersecting the areas of his torturers.*

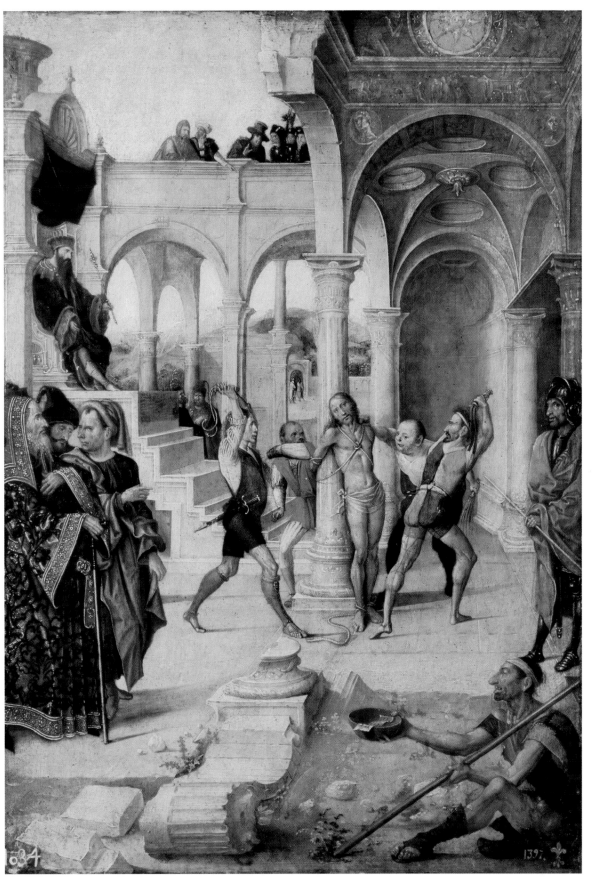

ALEJO FERNANDEZ *(1475–1543),* The Flagellation of Christ. *Fernandez fuses the historic, biblical period with his own era, as if to suggest that the biblical event is timeless. Christ is tied to a column and surrounded by the soldiers charged with exacting his punishment. An enthroned Caiaphas observes from above, while members of the council of high priests also look on. Above the courtyard, Peter can be seen denying Christ, as he is hounded by some of Christ's detractors and false witnesses. The curious placement of the blind beggar in the foreground is a reminder not only of some of the miracles performed by Christ, but of the type of humble character Christ's sacrifice will save in contrast to the arrogant people in power.*

47

Ecce Homo: Behold the Man

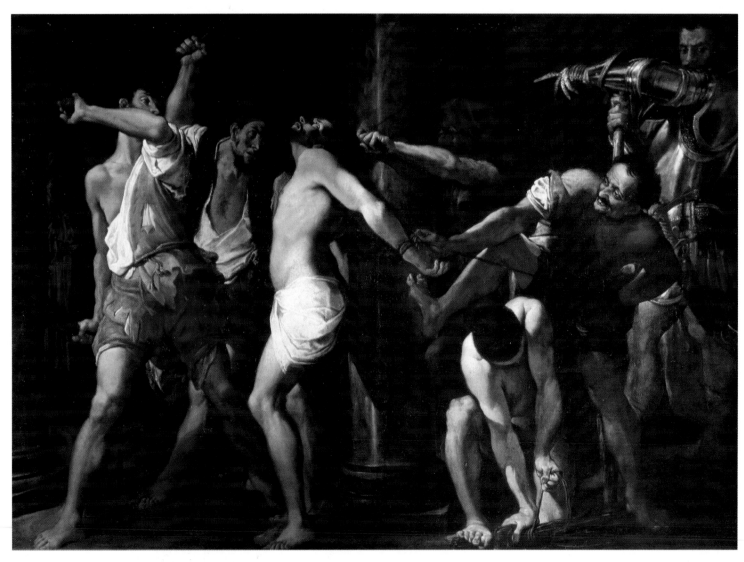

LUDOVICO CARRACCI, Flagellation of Christ (1585). Carracci's Flagellation is almost more about the ugliness of humankind and its potential for violence and evil than it is about Christ's torture. As is often depicted, Jesus is bound, but this scene concentrates on and illuminates the various activities of his torturers. One pulls Jesus' head back, another prepares his weapon, and another holds Jesus taut to the column, nearly spraining his arms, while still two others beat him. All the men in the painting are strong, athletic, physical examples of the classical male. Carracci alludes to the three crosses at Golgotha with broad intersecting vertical and horizontal elements that are highlighted by his strong use of light and dark (known as chiaroscuro).

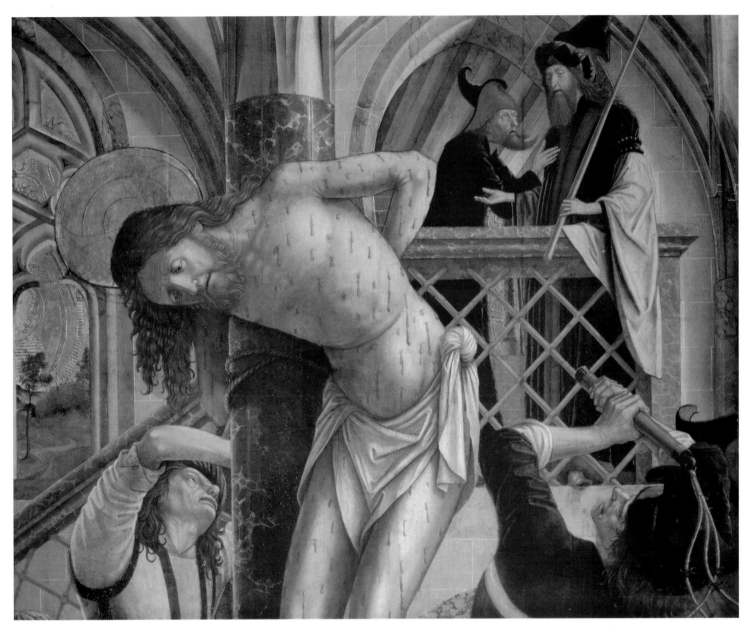

MICHAEL PACHER, The Flagellation of Christ *(1495–98). In this depiction, Pacher dramatically emphasizes Christ's suffering. A monumental figure tied to a column, Jesus is beaten with a cat-o'-nine-tails by a soldier while another tightens the tethers. The low viewpoint magnifies the blood that drips from each wound. The serpentine position of Jesus' body, his bowed head, and the intersection of the horizontal and vertical elements of the architecture evoke the actual crucifixion. In the background a chastened Judas discusses with a high priest his desire to return the bounty collected for his betrayal.*

Then the soldiers of the governor took Jesus into the governor's headquarters, and they gathered the whole cohort around him. They stripped him and put a scarlet robe on him, and after twisting some thorns into a crown, they put it on his head. They put a reed in his right hand and knelt before him and mocked him, saying, "Hail, King of the Jews!" They spat on him, and took the reed and struck him on the head. After mocking him, they stripped him of the robe and put his own clothes on him. Then they led him away to crucify him.

Matthew 27:27–31

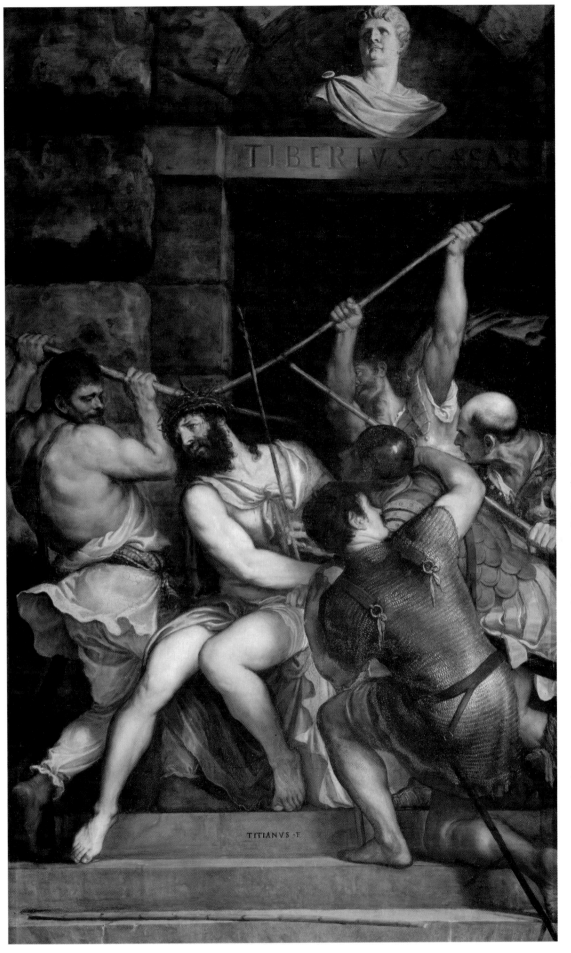

TITIAN (TIZIANO VECELLI), Christ Crowned with the Crown of Thorns (1542). *Titian, a master of color, depicts Christ as a Semitic man with characteristic dark, curly hair and features. The soldiers have draped him in a red cloak (sometimes described as purple in scripture) and seated him on a mock throne. Two even appear to kneel before him, pretending to pay him homage, while the others press the crown of thorns onto his head. Set in a dark, rusticated room with a bust of Tiberius set in an arch, this image is a reminder of the harsh cruelty of the historic period.*

51

Now Jesus stood before the governor; and the governor asked him, "Are you the King of the Jews?" Jesus said, "You say so." But when he was accused by the chief priests and elders, he did not answer. Then Pilate said to him, "Do you not hear how many accusations they make against you?" But he gave him no answer, not even to a single charge, so that the governor was greatly amazed. Now at the festival the governor was accustomed to release a prisoner for the crowd, anyone whom they wanted. At that time they had a notorious prisoner, called Jesus Barabbas. So after they had gathered, Pilate said to them, "Whom do you want me to release for you, Jesus Barabbas or Jesus who is called the Messiah?" For he realized that it was out of jealousy that they had handed him over. While he was sitting on the judgment seat, his wife sent word to him, "Have nothing to do with that innocent man, for today I have suffered a great deal because of a dream about him." Now the chief priests and the elders persuaded the crowds to ask for Barabbas and to have Jesus killed. The governor again said to them, "Which of the two do you want me to release for you?" And they said, "Barabbas." Pilate said to them, "Then what should I do with Jesus who is called the Messiah?" All of them said, "Let him be crucified!" Then he asked, "Why, what evil has he done?" But they shouted all the more, "Let him be crucified!" So when Pilate saw that he could do nothing, but rather that a riot was beginning, he took some water and washed his hands before the crowd, saying, "I am innocent of this man's blood; see to it yourselves." Then the people as a whole answered, "His blood be on us and on our children!"

Matthew 27:11–25

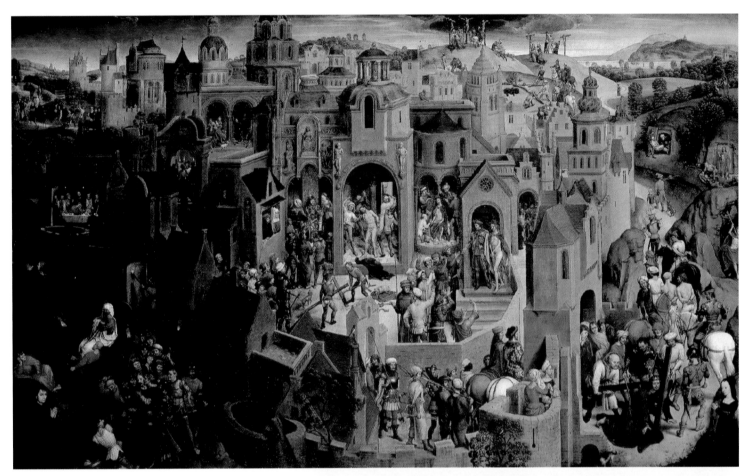

HANS MEMLING *(1425–1494), The Passion of Christ and detail of Pontius Pilate presenting Christ to the people. A typical northern Renaissance painting, Memling's* The Passion of Christ *depicts the entire countryside, the vast length of the walk to Golgotha, and Golgotha at the upper right, where the two thieves seem to already be crucified. In a progressive narrative, Memling shows the interiors of the building, allowing us to also see other parts of the story: the flagellation, mocking of Christ, and crowning with thorns. The scene is filled with both mundane and scriptural activities. In the detail, Pilate presents Christ, escorting him out of the building, still dressed in his mock-regal garb. A penitent Pilate is juxtaposed to the angry crowd, which denies Christ. They gesture angrily, skeptical of Christ, unrepentant in their desire to crucify him and unaware of the meaning of his sacrifice.*

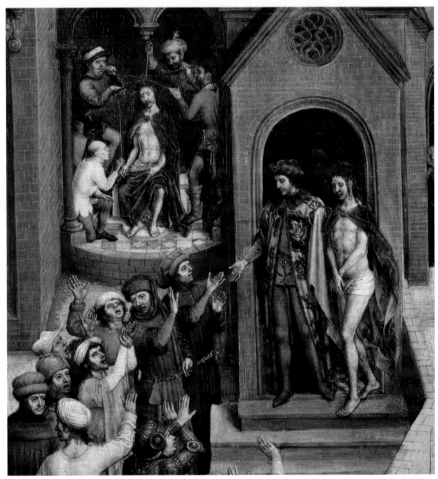

Ecce Homo: Behold the Man

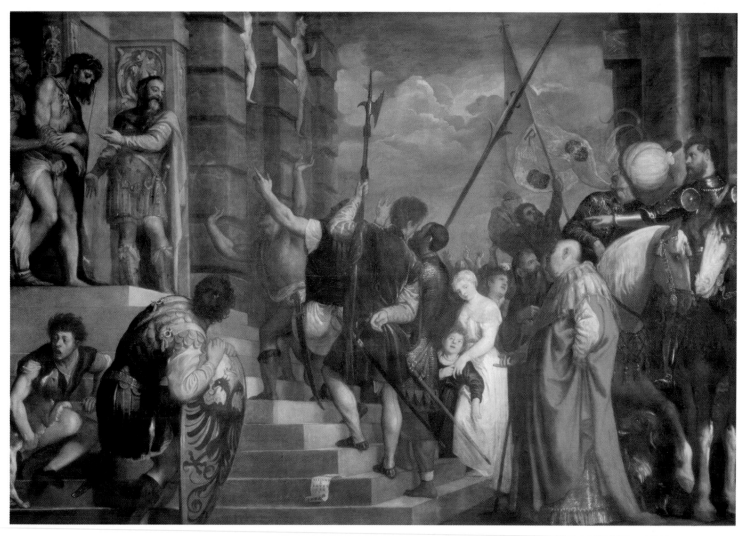

TITIAN (TIZIANO VECELLI), Ecce Homo (1543). Set in a Roman building of the type that may have existed during the reign of Tiberius, a bloody, tortured Jesus, wearing a crown of thorns, is led out onto the landing by a soldier. Pilate is slightly set apart from Jesus and is far from the crowd, physically distancing himself from the situation after having symbolically done so by washing his hands. While most of the figures in the scene are dressed in ancient garb, two figures—a woman and child—are illuminated and in sixteenth-century dress. The woman was most likely the donor of the painting. A common practice, the placement of contemporary figures into religious scenes allowed the donor or patron to become immortalized as bearing witness to a holy event.

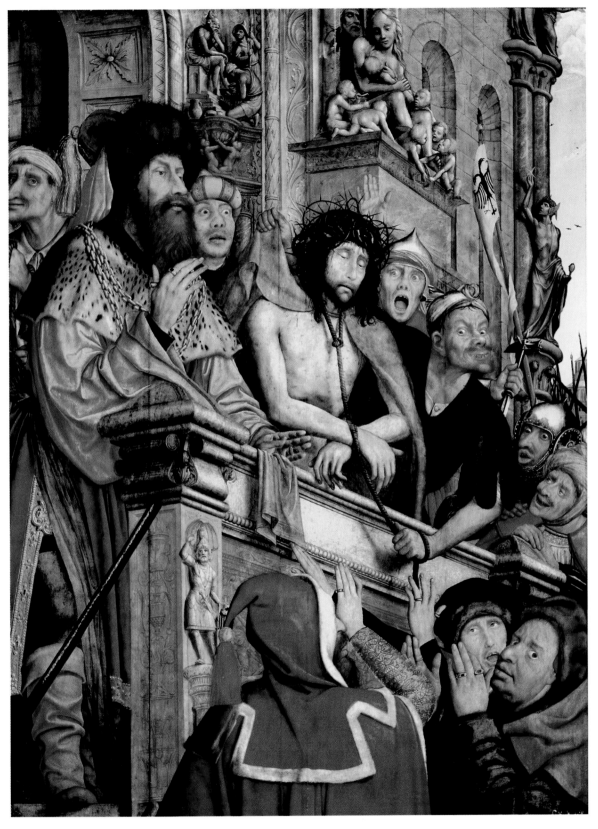

QUENTIN MASSYS, Christ Presented to the People (ca. 1515). A humble, tortured Jesus, crowned with thorns and draped in mock-regal robes, is presented to an unruly, angry mob. With a tether around his neck and his hands bound together, Jesus is treated like chattel in an image of the potential of human cruelty. A reserved Pilate, who has already washed his hands of the responsibility for Jesus' death, addresses the crowd. He is set apart from the rest of Jesus' detractors but still does not touch Jesus, distancing himself from the sentence. Above Jesus' head is a sculpture that evokes the Madonna and Child—a reminder of Jesus' divine birth and destiny as the Christ from his conception.

Ecce Homo: Behold the Man

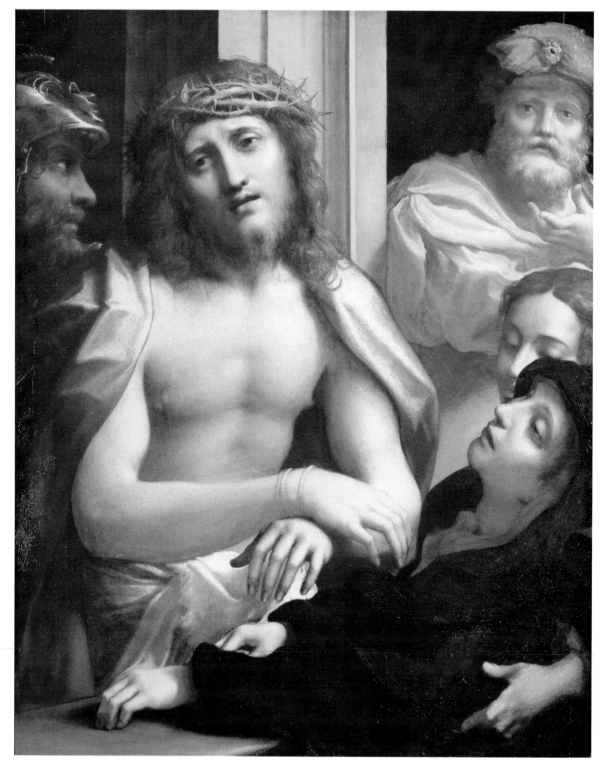

CORREGGIO, Christ Presented to the People *(1525–30)* **(Right)**. *In this touching scene, Pilate is behind Jesus, gesturing toward and looking directly at the viewer. It is us to whom he is saying, "Ecce Homo" ("Behold the man"), as well as to the unseen crowd. A soldier to Jesus' left is almost an incidental figure, as he is cast in shadow and barely in the scene. His complicit sin is emphasized by the darkness, while all the other figures are bathed in the light that emanates from Christ. A swooning Mary is included here, in a departure from the scriptural account. Correggio's placement of her is a reminder of the innate connection between Mary and Jesus, as she was the vessel that bore him.*

REMBRANDT HARMENSZ VAN RIJN, Christ Presented to the People *(ca. 1634)* **(Opposite)**. *Painted with a limited palette and heavy* impasto *(application of pigment), characteristics of Rembrandt's work, this scene emphasizes the psychological drama of the Passion. Pilate seems to address the high priests who are placed directly in front of him, rather than the crowd who is being controlled by the guard at the bottom right of the painting. An image of humility, Christ looks out at the viewer as he is led onto the platform. The bust of Tiberius and the clock above the gate seem to alert us to the passing of time, to the historic period, and to the eventual upset of a world over which Christianity will triumph.*

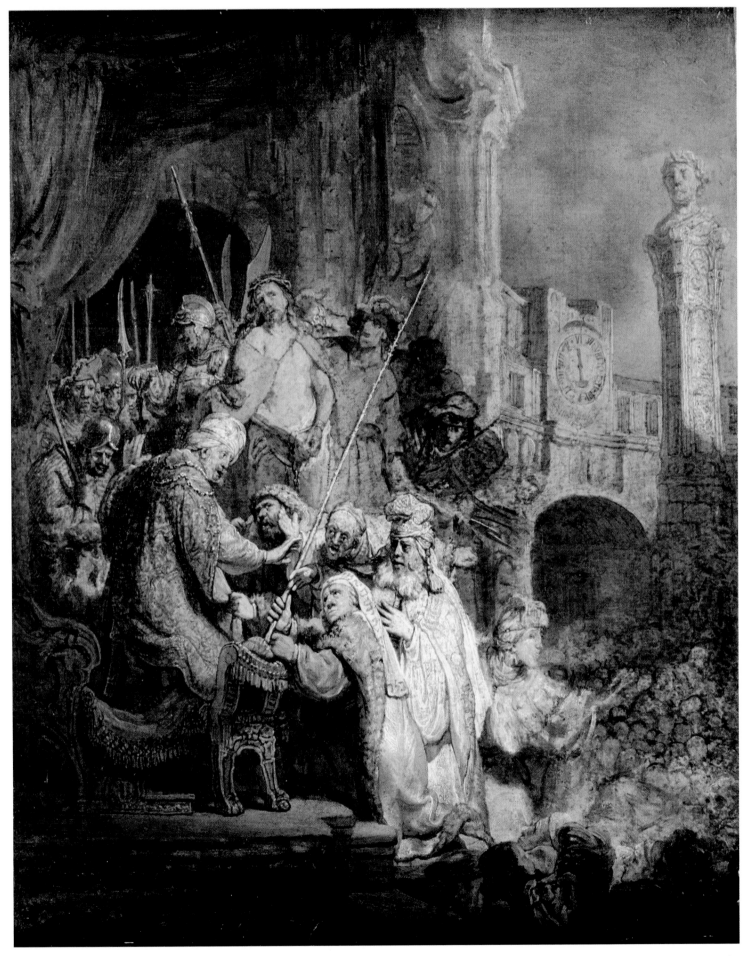

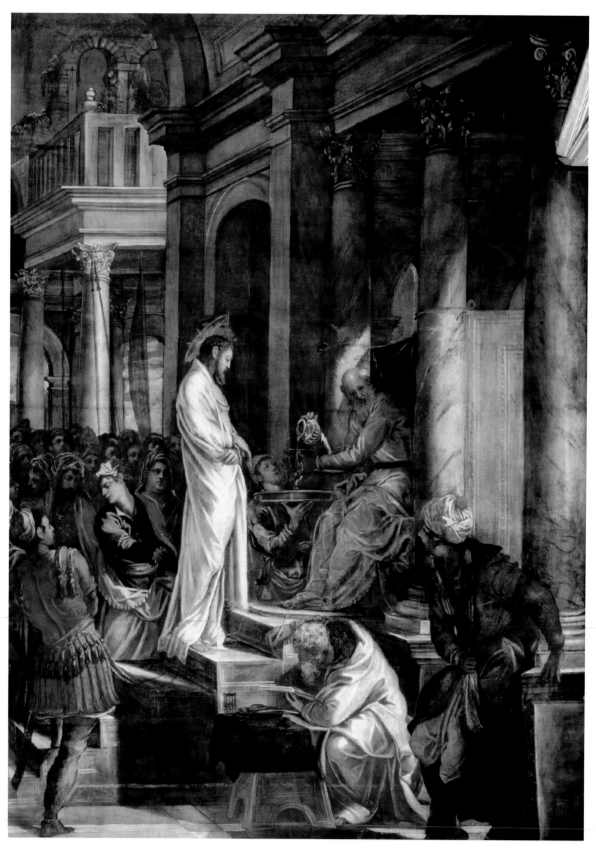

JACOPO ROBUSTI TINTORETTO, Christ Before Pilate *(1566–67).* *In this rendering, Christ and Pilate are centralized and illuminated. In fact, it seems as if the light is coming from Christ, radiating around him and in an orb that extends toward Pilate. Christ's white garb is a symbol of his purity and also evokes the shroud in which he will be buried. Next to Pilate is a servant who holds a tray and pours water from a vessel. Upon finding no crime, yet still being urged to condemn Christ, Pilate is about to wash his hands, absolving himself from the guilt of the sentence of crucifixion he must enforce.*

MATTHIAS STOMER, Pontius Pilate Washing His Hands *(1640). In the foreground, Pilate washes his hands, aided by his servant. He looks directly at the viewer, as if in a plea for forgiveness and to have us witness his self-absolution of the blood that he is complicit in shedding. Another servant reveals the scene by pulling back the curtain at the right of the painting. In the background, Jesus is led away, carrying his cross. Pious, with his head bent, he accepts his fate.*

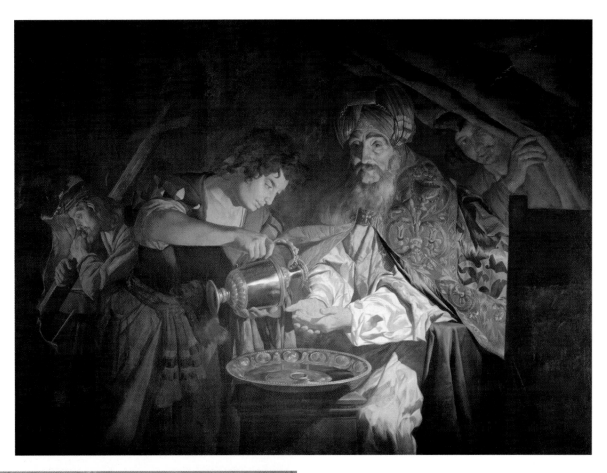

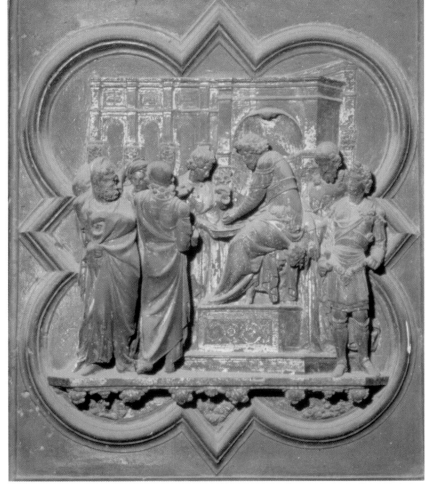

LORENZO GHIBERTI, Pontius Pilate Washing His Hands *(1403–24). This is one of several scenes from the New Testament made for the North Portal of the Baptistery of San Giovanni in Florence, located near the* duomo, *the cathedral of Santa Maria della Fiore. In this high-relief bronze sculpture, Ghiberti depicts the scriptural scene from the Gospel of Matthew— the only Gospel that describes this part of the Passion. Pilate washes his hands "before the multitude." The witnesses to Pilate's cleansing gesture direct their attention to him—except for one, whose attention is focused on the viewer entering the baptistery.*

The Long Walk
CHRIST CARRIES THE CROSS

After being beaten, mocked, crowned with thorns, and presented to the public, Christ is forced to walk to the site of his crucifixion, Golgotha. This pilgrimage of sorts is sometimes referred to as the "walk to Calvary." Golgotha, or "Place of the Skull," is named so because it is believed to be the site of the bones of Adam.

There is some disagreement among the four Gospels (Matthew, Mark, Luke, and John) about exactly what happened during Christ's walk to Calvary. Of the four, only John states that Jesus was made to carry his own cross. Additionally, none of the four Gospels fully describe the events that transpired during the walk to Golgotha, except that Simon of Cyrene (a region in Africa) helped Jesus carry the cross. These apparently apocryphal events became the body of the Stations of the Cross, a Lenten exercise performed by Catholics that includes prayers and petitions to Jesus and God while visiting each station. This is a way of preparing for Easter and of retracing Jesus' steps without having to physically go to Jerusalem.

The Renaissance and Baroque imagery associated with Christ's final walk is vivid. First, Jesus begins the walk with an immense wooden cross. Carrying the cross was a departure from the usual Roman practice. As part of their sentence, those condemned to crucifixion usually carried only the horizontal part of the cross, as the vertical post was already in place. Beneath the weight of a full cross and weak from his torture, Jesus falls. When depicting this scene, Renaissance and Baroque artists often used the device of placing Christ in the foreground of the image, as if he is about to fall into the viewer's space. Next, Jesus meets his mother, the Virgin Mary, for the first time since his arrest and trial. It is then that Jesus is helped by Simon of Cyrene at the behest of the soldiers.

Veronica, whose story is part of non-scriptural tradition, is held to be one of the women who followed Jesus on the walk to Calvary. She is not portrayed as one of his disciples, but as a woman along the way who wipes the sweat from his face with her veil. Miraculously, her veil becomes imprinted with his image.

Amid mocking from the crowd, Jesus falls a second time. As his journey continues, followers join him, some of whom are women from Jerusalem, who wail for him. It is here that Christ speaks, addressing the women specifically, saying to them, "Daughters of Jerusalem, do not weep for me, but weep for yourselves and for your children" (Luke 23:28), after which Christ falls a third time as he reaches Golgotha itself.

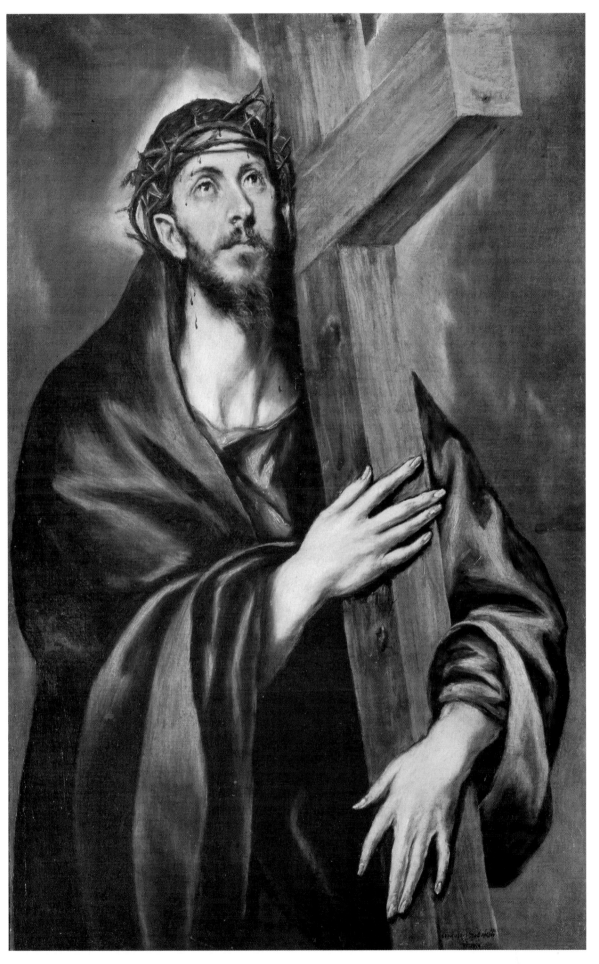

DOMENICO THETOCOPULI, CALLED EL GRECO, Christ Carrying the Cross (1600–05). *Fully encompassing the space of the canvas, Christ holds the cross upright, cradling it, knowing it is an instrument of his destiny. Unlike images of a tortured Christ, burdened by the weight of the cross, here he is triumphant. Although blood drips from his crown of thorns, he is radiant—in fact, an aureole of light emanates from him. With eyes cast toward heaven, Christ is resolved and at peace with his sacrifice.*

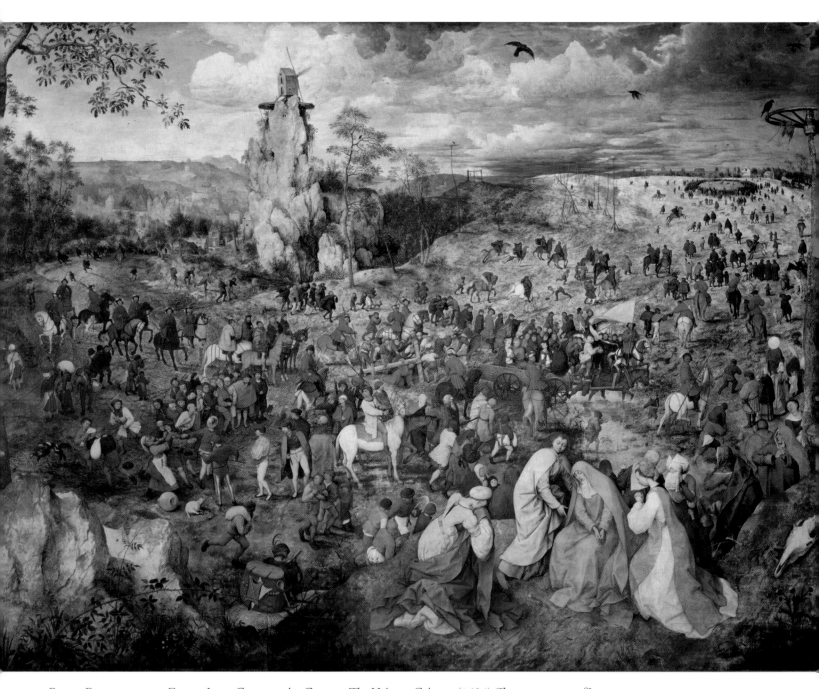

PETER BRUEGHEL THE ELDER, Jesus Carrying the Cross or The Way to Calvary (1564). *This vast scene of Jesus Carrying the Cross is filled with activity. It is set in northern Europe, identified by the windmill at the top of the tall craggy cliff. Christ is in the center of the painting, but one must really look for him, as he is surrounded by chaos. In the foreground, Mary, his mother, rests, seated in a position that evokes the Madonna and Child. But here her child is out of her reach and about to die. Christ's suffering is contrasted with the apparent apathy of the spectators and people who seem to be continuing their daily mundane duties.*

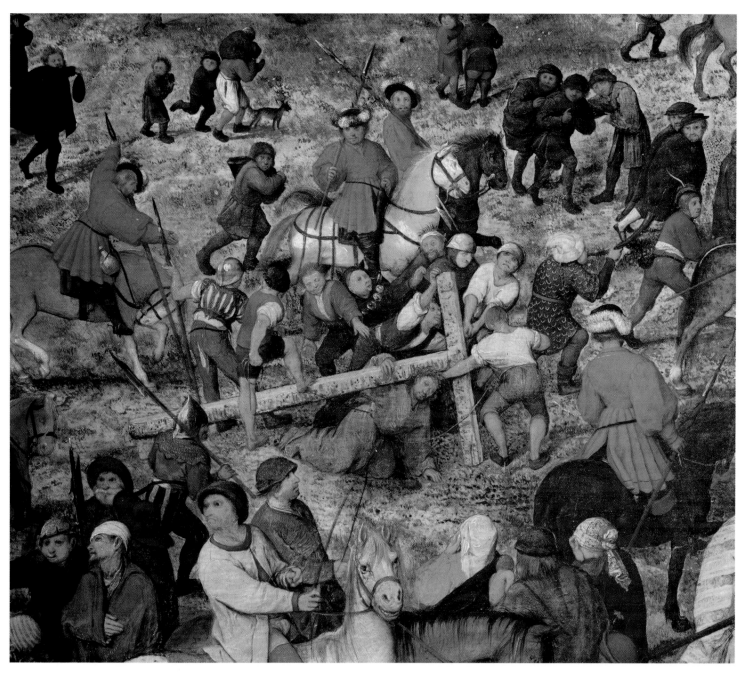

In this detail of Jesus Carrying the Cross, *Christ has fallen beneath the weight of the cross, which is so heavy that even a team of burly men cannot easily lift it. Several of the figures in this scene are unaware that Jesus has fallen, while one in particular seems to further punish Christ by putting his weight and right foot upon the cross while Christ is down.*

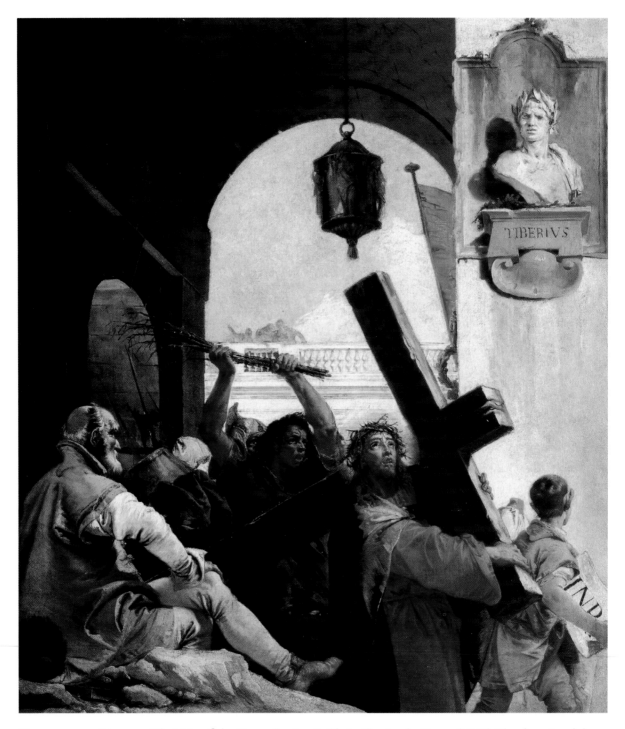

GIAMBATTISTA TIEPOLO, The Way of the Cross: Station 2, Christ Carries the Cross *(1749). Tiepolo painted the fourteen Stations of the Cross for the church of San Polo in Venice. This church has foundations that date to the ninth century A.D., and its ancient roots are the perfect setting for these historic scenes. In* The Way of the Cross: Station 2, *the procession leaves Pilate's quarters. Dragging the cross, but not yet overwhelmed by its physical weight, Christ looks upward for guidance and strength from God as he begins the walk to Calvary. Above him is a bust of Tiberius, in whom Jesus' contemporaries have their faith, rather than in God. Tiberius (a caesar) is juxtaposed with the inscription of "I.N.R.I." carried by the scribe below. Although this inscription was not actually drafted until Christ reached Golgotha, it is included here to make the direct comparison between an earthly and a heavenly king.*

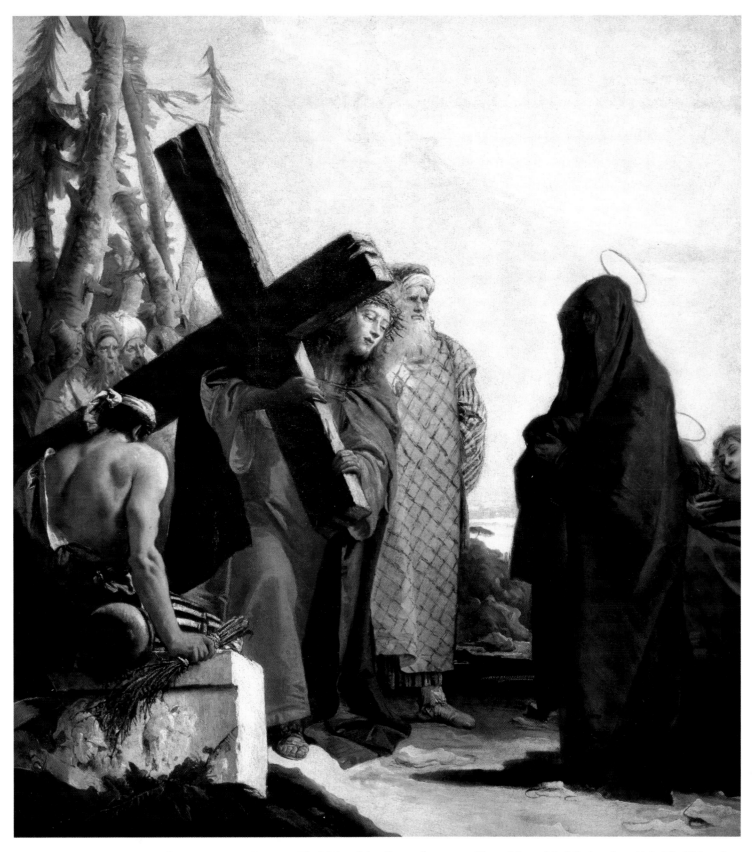

GIAMBATTISTA TIEPOLO, The Way of the Cross: Station 4, Christ Meets His Mother *(1749). In The Way of the Cross: Station 4, we see a more exhausted Christ, as he continues to drag the cross that will bear his body. Here he meets his mother, Mary. The apostle John has taken her to see her son before he dies. She is fully veiled, her face covered, as if to suggest that she is already in mourning.*

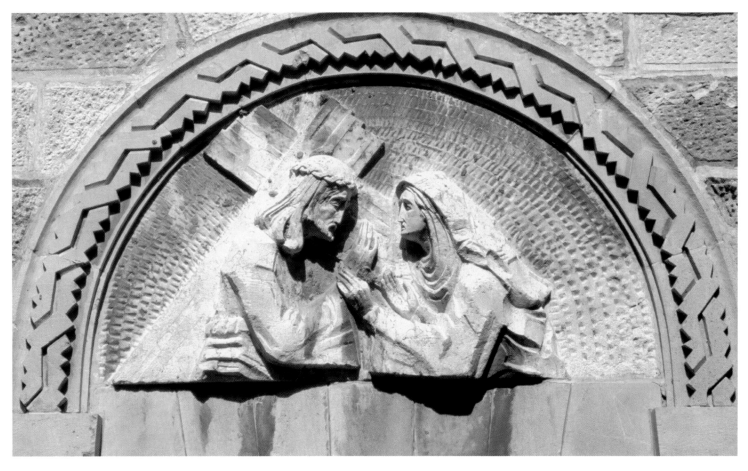

ANONYMOUS, Station Four on Via Dolorosa *(15th century). Carved in deep relief above the door of the Fourth Chapel along the Tyropeon Valley in Jerusalem, this image is of Christ meeting his mother. The building itself dates to the fifteenth century. The deeply carved image shows Mary clasping the hand of her son, unwilling to let go, although she knows she must. Despite the rough-hewn carving, the position of the figures is so sensitive that it is nearly impossible not to see and feel Mary's torment.*

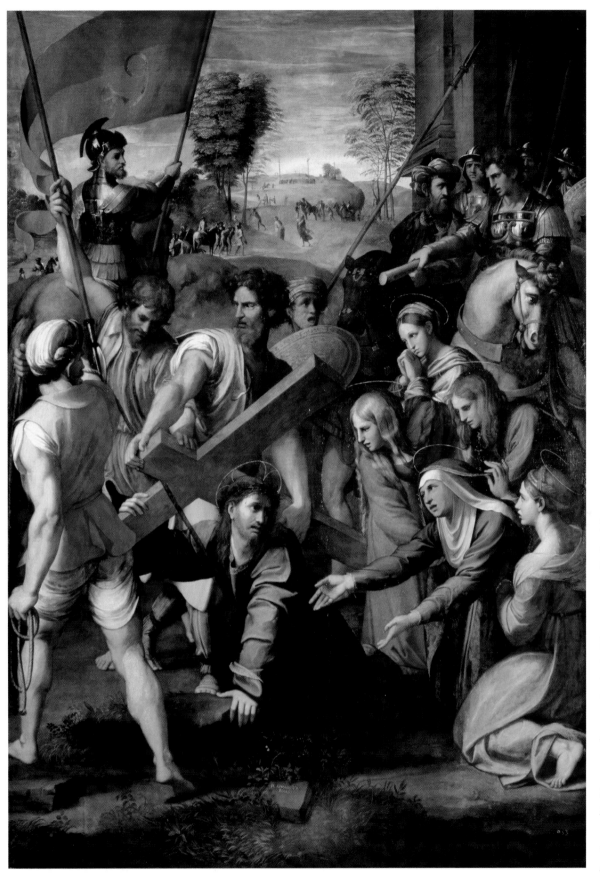

RAPHAEL SANZIO, Lo Spasimo di Sicilia (Christ on the Way to Calvary) (1516). In this version of the scriptural account, Raphael portrays the procession as moving in a somewhat circular course. First, they come out from the right and head toward the foreground, then at the left they turn back into the landscape. Christ is placed front and center, falling as he turns to look back at the figure of Mary, who reaches out for her son with longing.

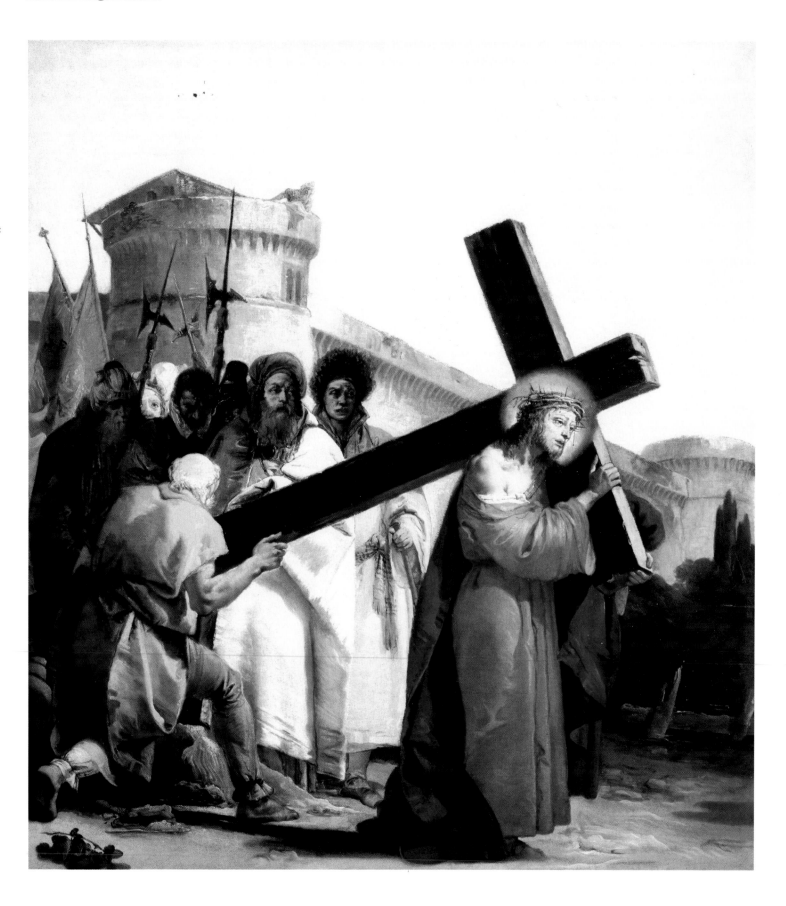

As they led him away, they seized a man, Simon of Cyrene, who was coming from the country, and they laid the cross on him, and made him carry it behind Jesus. A great number of the people followed him, and among them were women who were beating their breasts and wailing for him. But Jesus turned to them and said, "Daughters of Jerusalem, do not weep for me, but weep for yourselves and for your children. For the days are surely coming when they will say, 'Blessed are the barren, and the wombs that never bore, and the breasts that never nursed.' Then they will begin to say to the mountains, 'Fall on us'; and to the hills, 'Cover us.' For if they do this when the wood is green, what will happen when it is dry?" Two others also, who were criminals, were led away to be put to death with him. When they came to the place that is called The Skull, they crucified Jesus there with the criminals, one on his right and one on his left.

Luke 23:26–33

GIAMBATTISTA TIEPOLO, The Way of the Cross: Station 5, Simon of Cyrene Helps Christ Carry the Cross *(1749)* **(Opposite)**. *A pale, weakened Christ reaches the limits of the Roman gates in* The Way of the Cross: Station 5. *Clearly struggling beneath the weight of the cross, Jesus is helped by Simon of Cyrene. Depicted by Tiepolo as an old man, Simon's strength lies in direct contrast to Christ's human weakness. With each image in this narrative, Christ's physical suffering grows, but Tiepolo emphasizes his spiritual strength by increasing the radiance of his halo.*

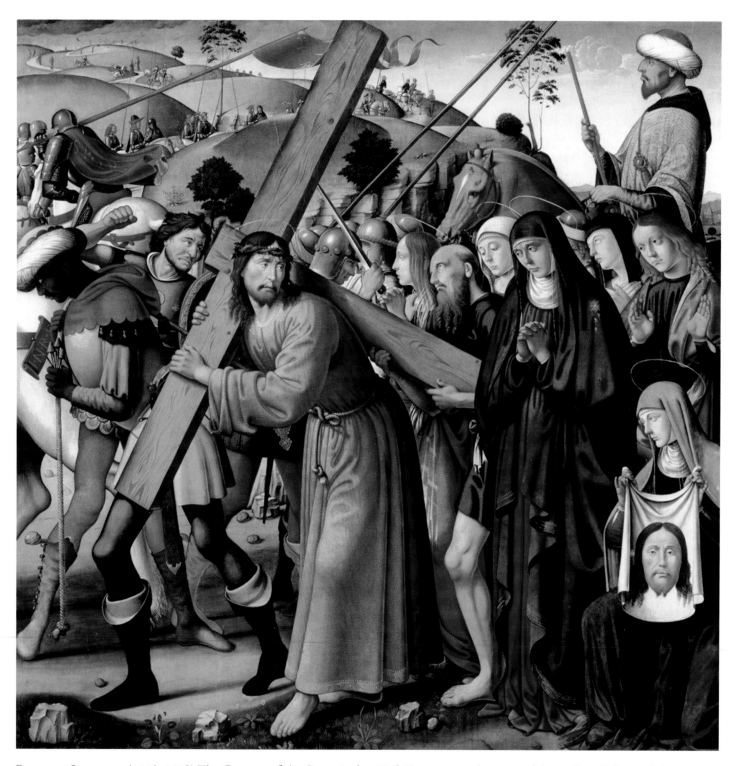

BIAGIO DI ANTONIO (1446–1508), The Carrying of the Cross. *In this High Renaissance depiction of the walk to Calvary, di Antonio places Christ in the center of the painting. Behind him are the holy figures in the story, one of whom is his mother. He looks back at her, and she at him, her hands clasped in prayer. Also with Mary are the other two Marys, John, and one of the weeping women of Jerusalem. Behind them, but set slightly apart from them, is Pilate on horseback. Simon of Cyrene helps Christ with the cross, while Veronica displays the image-bearing veil. At the left of the painting are the soldiers and Christ's accusers—all the figures who are part of the earthly reason for his death. The African soldier in front of Christ carries the sign that reads "I.N.R.I." and the nails that will secure Christ to the cross.*

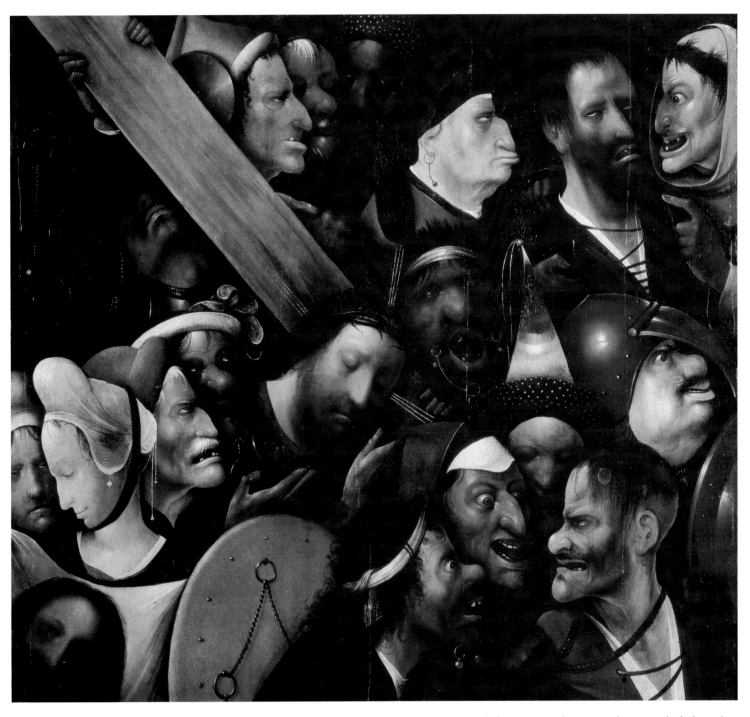

HIERONYMUS BOSCH, Christ Carrying the Cross (1515). *Bosch depicts a stark contrast between the holy and the damned. Painted as a close-up of the figures in the processional of the walk to Calvary, this image is a study of how outer appearance relates to the interior of the soul. The two pious figures—Christ and Veronica—are in repose, their eyes closed, as if deep in thought or prayer. All the other figures are strikingly ugly. Their eyes are open, and they stare, covet, gossip, and argue with each other. Bosch captures the character and psychological interiors of the people represented, even if it is in an exaggerated manner.*

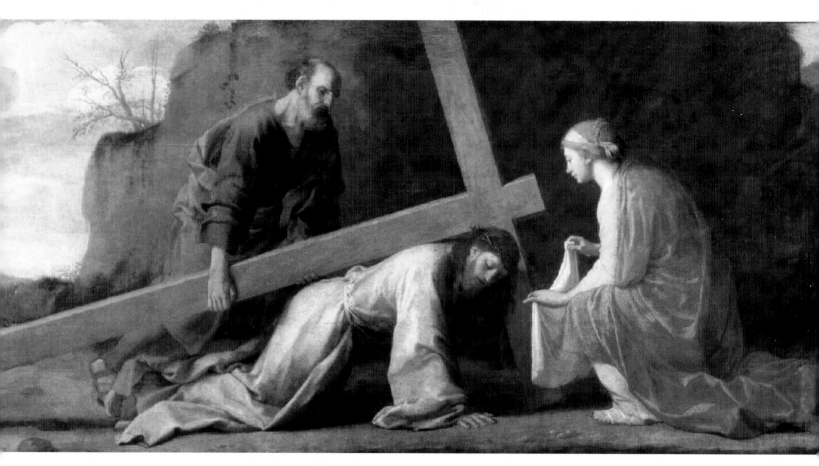

EUSTACHE LESUEUR, Christ Carrying the Cross (1651). *Departing from scripture, Lesueur depicts Christ as still being dressed in the mock-regal garb given to him by the Roman soldiers. In another departure from scripture, Veronica greets Christ, genuflecting before him. She is ready to wipe the blood and sweat from his face, unaware that his radiance is so magnificent that his very image will remain upon her veil.*

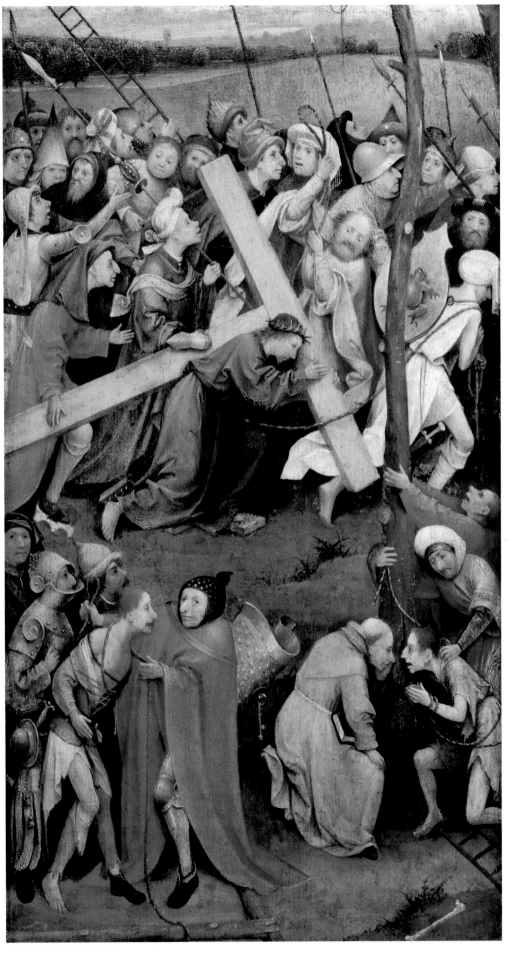

HEIRONYMUS BOSCH, Christ Bearing the Cross (1480–90). *Set in the center of the painting, a burdened Christ struggles to carry the cross, which is significantly larger than he is. Surrounded by spectators and soldiers, one of whom carries a ladder to aid in the crucifixion, Christ is tired and physically weak. The scene is activated by the spears, ladder, cross, and tree pointing in various directions. The two thieves also marked for death by crucifixion are included here, placed in the foreground. Also in the front of the painting is a bone, suggesting that the group has arrived at Golgotha, believed to be the site of Adam's bones, the location of the crucifixion.*

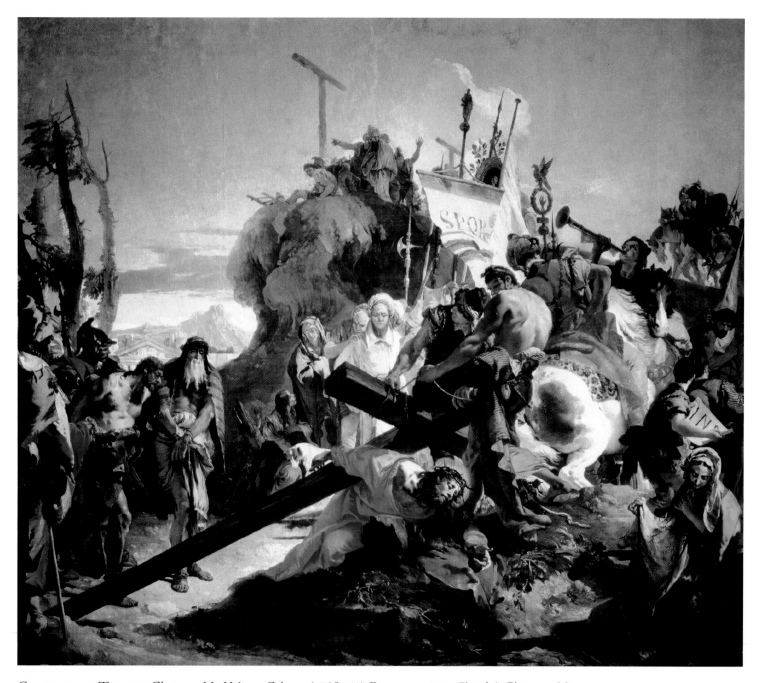

GIAMBATTISTA TIEPOLO, Christ on His Way to Calvary (1738–40). Baroque painter Tiepolo's Christ on His Way to Calvary is part of a larger triptych that includes Christ Crowned with Thorns and The Flagellation. Painted for the cloistered nuns of S. Alvise in Venice, this moving narrative was intended to highlight Christ's suffering and pain and to remind the nuns of their reason for worship and for being. Christ's cross is nearly twice his size, a burden almost too much to bear. Behind him, the two thieves are bound, but they stand without their crosses, which are already in place at the top of the mountain on Golgotha. Near Golgotha is a phoenix, an ancient mythological creature that here signifies the resurrection. Ahead of the processional, a soldier carries the Roman flag with "SPQR" imprinted upon it—a further reminder that it was the Senatus Populusque Romanus (Senate and People of Roma) that condemned Christ to death. To the right, Veronica faces outward, displaying the veil that bears Christ's image.

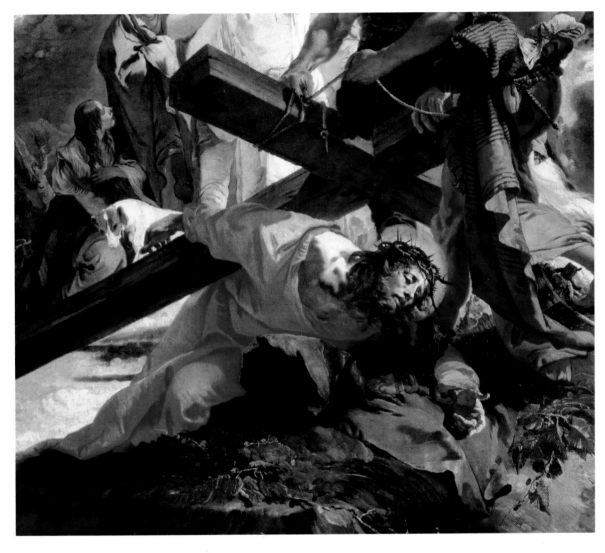

In this detail of Christ on His Way to Calvary, *the focus is on his face, bloodied from the crown of thorns. His body has been weakened from the physical and emotional weight of the cross, although Simon of Cyrene helps him. Almost positioned as if already crucified, Jesus reaches out with his left hand, index finger extended. Such a gesture is an allusion to Michelangelo's* Creation of Adam *from the Sistine Chapel ceiling, a reference with which the nuns of S. Alvise would have been familiar. This serves as a reminder that just as God gave Adam physical life, Christ, through his sacrifice and death, gave humanity a second, spiritual life.*

MICHELANGELO BUONARROTI, Creation of Adam, *detail from the Sistine Chapel ceiling (1508–12). This fresco, taken from the sixth bay of the Sistine ceiling, represents the sixth day from the Book of Genesis in the Old Testament. In it, after creating Adam, a strong, heroic figure of God gives life to a limp, claylike Adam through a simple touch.*

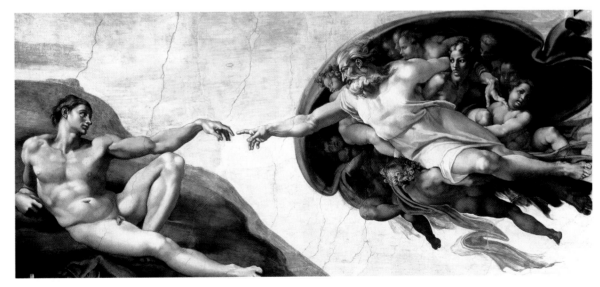

GIAMBATTISTA TIEPOLO, The Way of the Cross: Station 9, Christ Falls for the Third Time *(1749). The gathering crowds increase at each stage of Tiepolo's paintings, as witnessed in* The Way of the Cross: Station 9. *The closer Christ gets to Golgotha, the weaker and nearer to death he physically appears. A figure with his back toward us seems to stand in for the viewer, as a witness to, but not a participant in, Christ's sacrifice.*

GIAMBATTISTA TIEPOLO, The Way of the Cross: Station 10, Christ Is Stripped of His Garments *(1749). In* The Way of the Cross: Station 10, *Tiepolo dramatically places Christ in white, whereas in the previous images he was clad in red and blue. This white symbolizes his purity, holiness, and divinity. Two spectators (one of whom stands with a child, both in eighteenth-century dress) now engage us as viewers, whereas in the other images in the series such figures merely stood in for us. We are asked to focus our attention upon Christ's sacrifice and his dual nature of being divine and human.*

It Is Finished

HIS CRUCIFIXION AND DEATH

Upon reaching Golgotha, Christ is stripped of his garments. Pilate has a sign fashioned to read "Jesus of Nazareth, King of Jews" in Greek, Latin, and Hebrew. The Latin letters, I-N-R-I, stand for *Iseus Nazarenes Rex Iudaeorum* ("I" is a Latin "J" in our alphabet), which is the phrase most associated with the inscription on the cross. In Renaissance and Baroque art it is usually the only inscription depicted. The sign is placed at the top of the cross, and then Jesus is nailed to the cross. After Jesus is stripped and crucified, four soldiers divide his tunic among themselves, a piece for each, but they cast lots for his cloak, a seamless garment woven in one piece from the top. A parallel can be made between Joseph's cloak of many colors and Jesus' cloak, for both involve the fulfillment of prophecy or scripture. According to the Gospel of John, the soldiers decide not to tear the cloak, thus fulfilling what the scripture had said (John 19:24).

Christ is placed between two criminals: the penitent criminal on his right, the other on his left. At his feet are the three Marys—Jesus' mother; Mary Magdalene; and Mary, the wife of Clopas and mother of James and Joseph. John, the writer of the Gospel and Jesus' disciple, is also at his feet. For the second time, Christ speaks, saying directly to his mother, "Woman, here is your son," and to John, "Here is your mother" (John 19:26–27).

While on the cross, Christ endures yet more mocking and is told to prove his divinity and save himself. According to the scriptural accounts, between noon and three o'clock in the afternoon darkness overtakes the land. Christ begs of thirst and is given a sponge soaked with vinegar (or sour wine) to drink from, after which he cries out in Hebrew to God, "Why have you forsaken me?" He then says, "Father, into your hands I commend my spirit.… It is finished," and dies (Mark 15:33–34; Luke 23:46; John 19:30).

In the Roman Empire, crucifixion was a punishment reserved for the lowest of criminals. Nailed to the cross, the crucified suffered an agonizing death. Not only was there excruciating pain from the nails, but also from the weight of their bodies being drawn at the arms and the diaphragm being compressed. It was a lengthy, torturous punishment. It is believed that in order to speed up the dying process, the legs of the criminals were broken. But when the centurion noticed that Christ appeared dead already, he did not break Christ's legs but did pierce his side. Christ's piercings (side, hands, and feet) have become some of the most powerful and emotive symbols of his Passion.

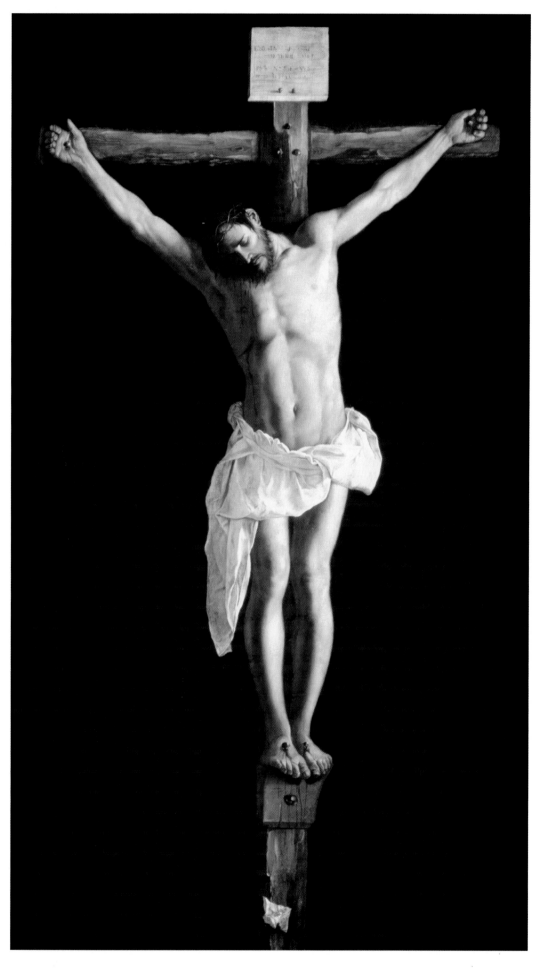

FRANCISCO DE ZURBARÁN, The Crucified Christ (1660s). The Crucified Christ *is one of Zurbarán's later works, created for the Church of St. Paul in Seville. The focus of this portrayal is not upon Christ's suffering on the cross but upon the heroic nature of his sacrifice. Pale and sculptural, Christ's body is monumental, positioned upright and secured to the cross by four nails instead of the traditional three, giving the figure balance and stability. The light coming in on Christ's left side and the dark background suggest the moment when he lowers his head, says, "It is finished," and dies. Within this poignant moment, Christ is both a tragic figure and a spiritual hero.*

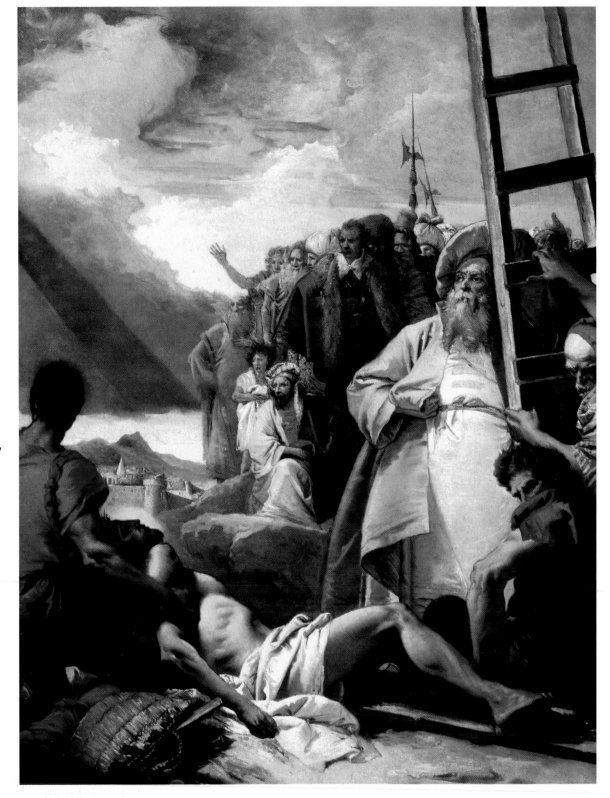

GIAMBATTISTA TIEPOLO, The Way of the Cross: Station 11, Christ Is Nailed to the Cross (1749). *This painting seems to hint at the lamentation yet to come. As the crowd watches, the soldier, struggling beneath the near-dead weight of Christ's body, situates Christ on the cross. Already the skies are beginning to change, the light in the distant background becoming eclipsed by clouds. The key moment is soon at hand.*

Over his head they put the charge against him,
which read, "This is Jesus, the King of the Jews."

Matthew 27:37

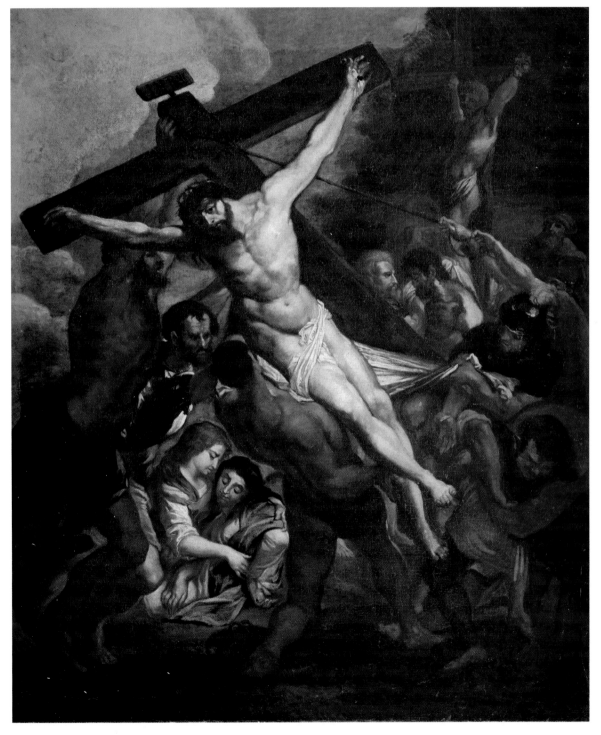

PETER PAUL RUBENS, The Raising of the Cross (1620–21). This oil sketch, intended for the ceiling of the Jesuit church in Antwerp, shows an unsettling, unstable image. A group of men hoist the crucified Christ from the ground, where he was nailed to the structure, while Mary Magdalene and Jesus' mother swoon from the emotional weight and gravity of the event. The diagonal position of Christ's body on the cross is set in contrast to the soldiers moving in various directions, furthering the sense of tumult in the scene.

81

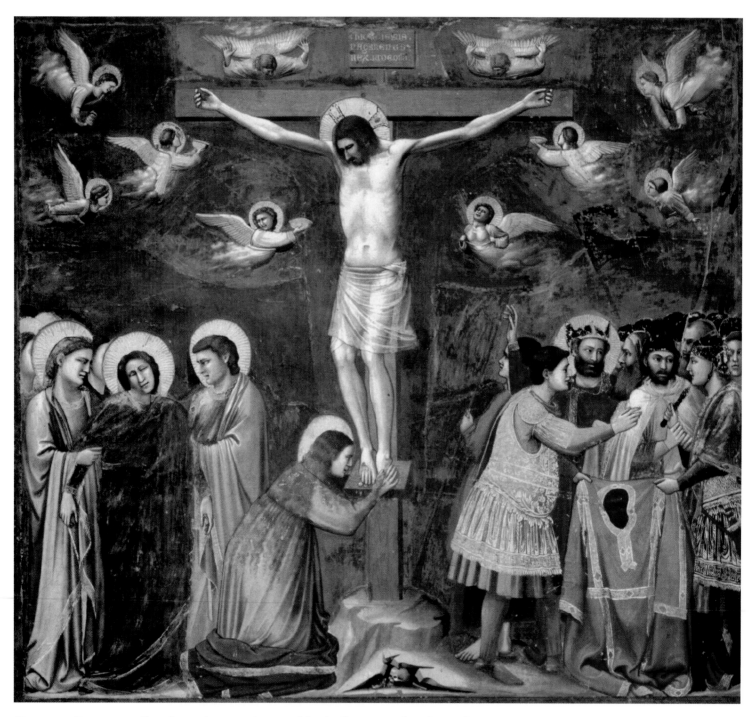

GIOTTO DI BONDONE, *Crucifixion (1304–13). Painted for the Scrovegni Chapel in Padua, Giotto's fresco of the crucifixion visually separates sinners from saints. The centrally placed crucified Christ is surrounded by a multitude of angels, who will lift his soul to heaven. Directly below Christ, Mary Magdalene kisses his bloody feet, anointing them not with oil, as she did before Christ's triumphal entry into Jerusalem (John 12:3) but with her tears. The trio of Jesus' mother Mary, John, and the third Mary stand in direct opposition to the group of spectators and the soldiers casting lots for Christ's cloak. Christ's role as the one who vanquishes original sin is expressed by Giotto's placement of the cross, directly on top of Adam's skull.*

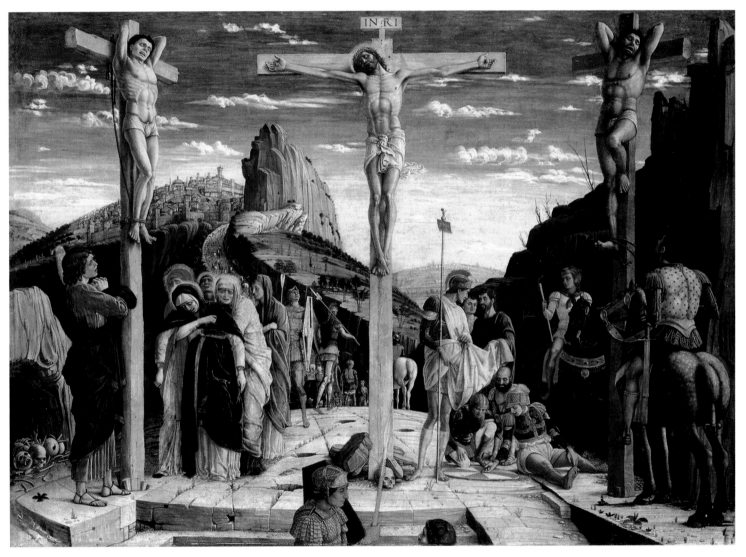

ANDREA MANTEGNA, Calvary (1456–60). Mantegna makes it clear that Golgotha translates into "skull place" by positioning Christ's cross directly on top of the skull of Adam and placing other human bones in the cave on the left side of the painting. Christ's blood drips down the cross and onto Adam's skull, signifying Christ's redemption of the original sin created by Adam (and Eve). Between Christ and the thief on the left is the grief-stricken Mary, while the disciple John stands to the left of the same thief. Unlike the thieves, who are placed in front of elements in the landscape, there is nothing behind Christ except sky, suggesting his heavenward journey. Both of the thieves are tied to their crosses rather than nailed. The scene is sometimes depicted this way to emphasize Jesus' suffering and sacrifice.

It Is Finished

And about three o'clock Jesus cried with a loud voice, "Eli, Eli, lema sabachthani?" that is, "My God, my God, why have you forsaken me?" When some of the bystanders heard it, they said, "This man is calling for Elijah." At once one of them ran and got a sponge, filled it with sour wine, put it on a stick, and gave it to him to drink. But the others said, "Wait, let us see whether Elijah will come to save him." Then Jesus cried again with a loud voice and breathed his last.

Matthew 27:46–50

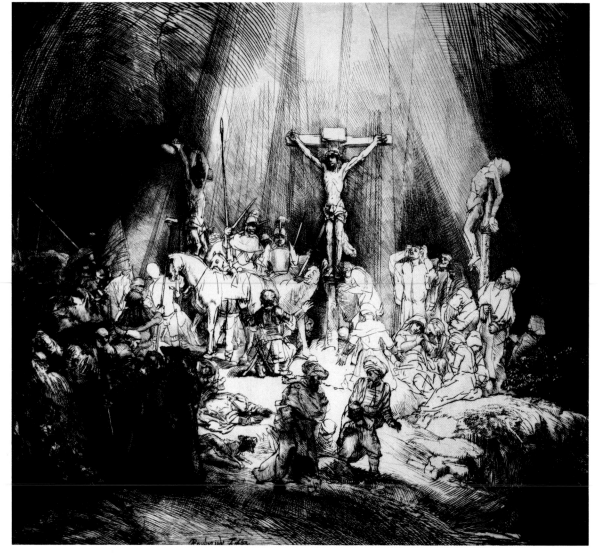

REMBRANDT HARMENSZ VAN RIJN, The Three Crosses (1653). In this engraving, Rembrandt illustrates the moment when Christ dies. Although in the scripture "darkness came over the whole land" (Mark 15:33), Rembrandt bathes Christ in light coming down upon him from the heavens, while casting the rest of the figures in shadow. Although Christ is dying, Rembrandt positions him as a heroic figure. Unlike the two thieves, his body is straight and powerful.

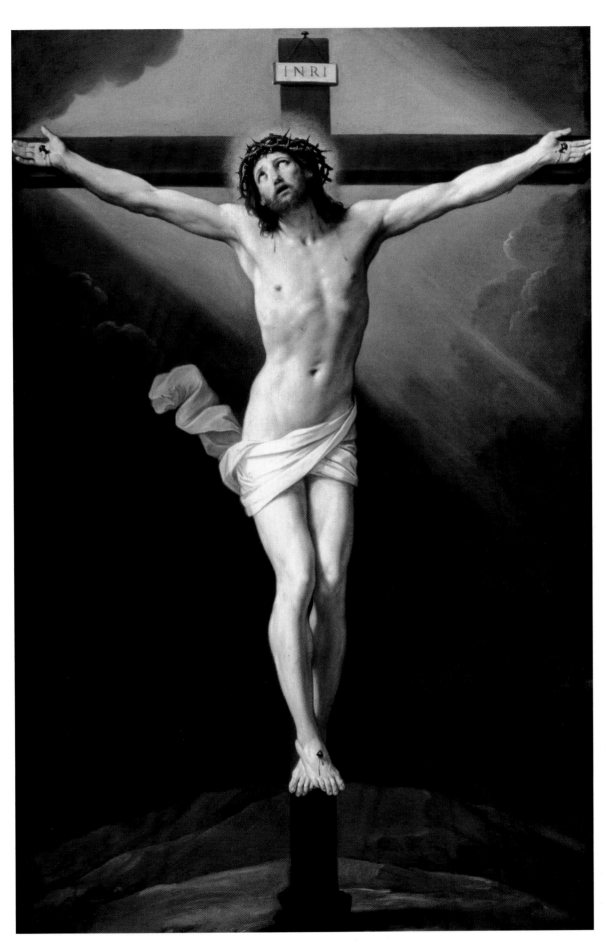

GUIDO RENI, Crucifixion (ca. 1610). *Evocative of Reni's* Ecce Homo, *this image presents a full-length figure of the crucified Christ. The cross and Christ's body fill the canvas, and the dark background suggests the moment of his death, when darkness fell over the land. Christ's gaze is heavenward, his eyes and mouth wide open. The movement of his covering suggests that it is windy. This movement, coupled with the opening in the clouds, seems to signify Christ's change from mortal to immortal.*

But when they came to Jesus and saw that he was already dead, they did not break his legs. Instead, one of the soldiers pierced his side with a spear, and at once blood and water came out. (He who saw this has testified so that you also may believe. His testimony is true, and he knows that he tells the truth.) These things occurred so that the scripture might be fulfilled, "None of his bones shall be broken." And again another passage of scripture says, "They will look on the one whom they have pierced."

John 19:33–37

And I will pour out a spirit of compassion and supplication on the house of David and the inhabitants of Jerusalem, so that, when they look on the one whom they have pierced, they shall mourn for him, as one mourns for an only child, and weep bitterly over him, as one weeps over a firstborn.

Zechariah 12:10

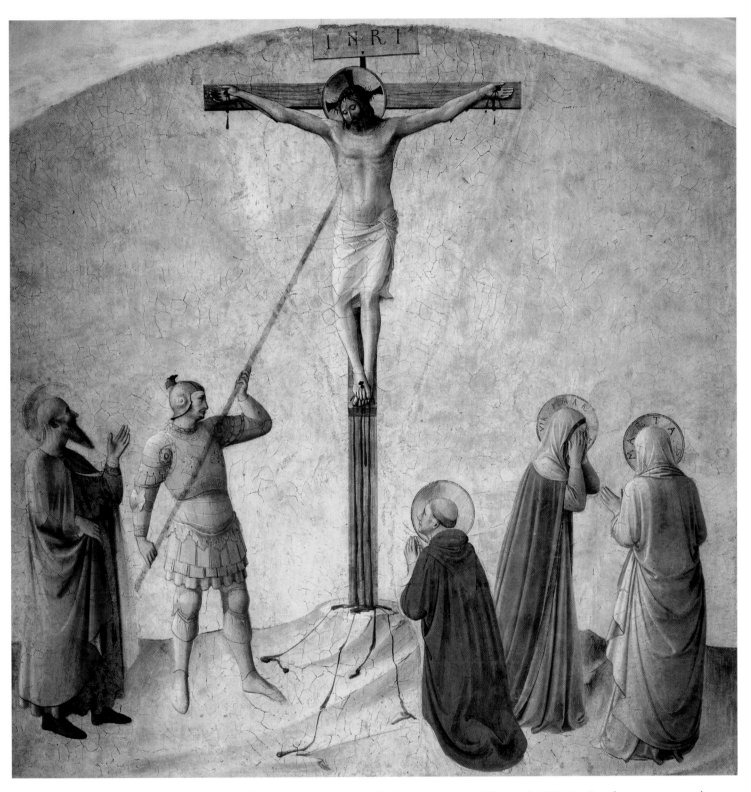

FRA ANGELICO, Crucifixion with Virgin, Soldier Longinus and Saints *(1438). Fra Angelico paints a stark scene. The crucified Christ is central, taking up almost the entire height of the space. Below him is his mourning mother, her back turned away from him. She is consoled by another Mary. A friar, perhaps Saint Francis (a figure who is not part of the scriptural account), kneels before Christ. To the left of Christ is John the Evangelist, who gestures toward Christ. Despite all the emotions expressed, the real drama of the scene is created by a soldier (named Longinus in Catholic tradition), who pierces Christ's side.*

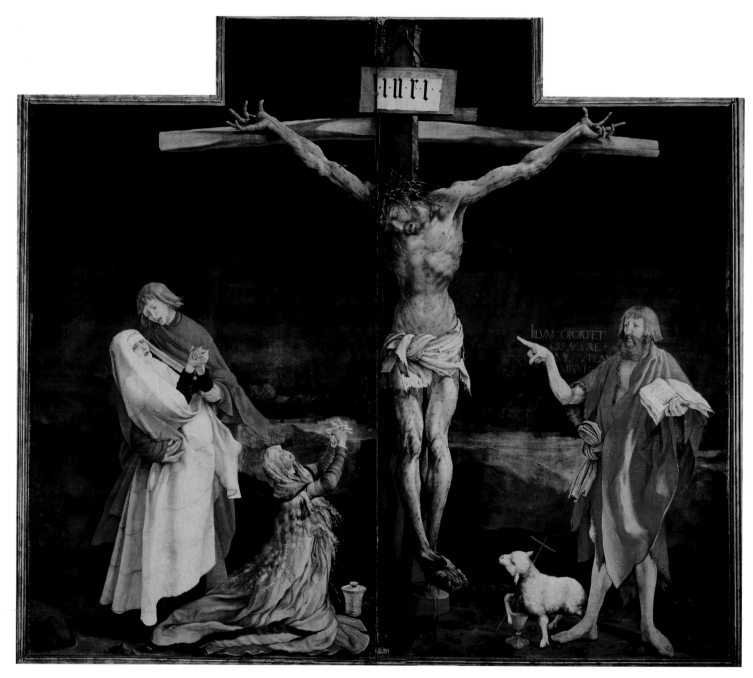

MATTHIAS GRUENEWALD, Crucifixion *from the Isenheim Altarpiece (ca. 1515). This image is the exterior of the central panel of the Isenheim Altarpiece. Set in a bleak, dark landscape, the scene shows Mary Magdalene at Jesus' feet and Mary (Jesus' mother) being comforted by John the Evangelist. John the Baptist (a symbolic figure in this depiction, since he died before the crucifixion) points to the tortured, contorted figure of Christ. Next to Mary Magdalene is a jar, probably filled with oil. A lamb bearing a cross, a symbol of Christ's sacrifice, is beside the feet of John the Baptist. Jesus' features are elongated and contorted, and he is portrayed as being much larger than the other figures. In this way, Gruenewald takes Christ's suffering on the cross to the extreme.*

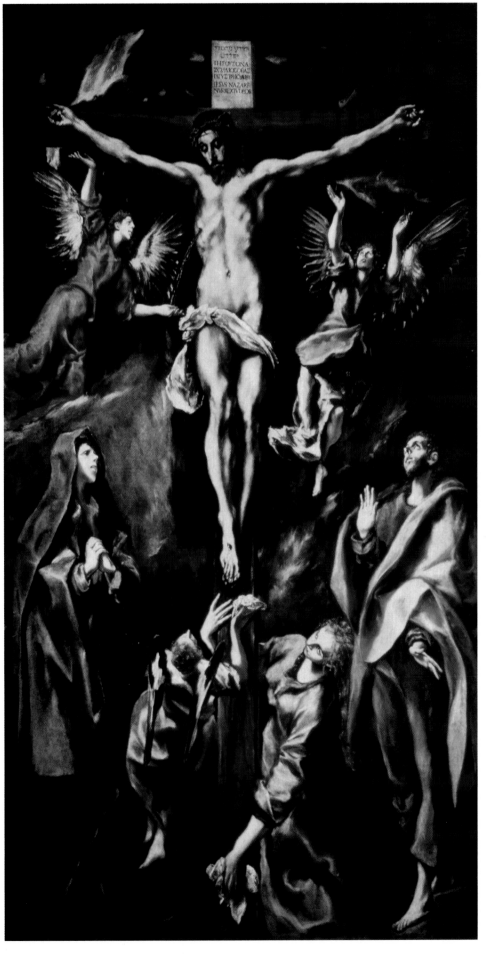

DOMENICO THETOCOPULI, CALLED EL GRECO, Christ on the Cross with Saint Mary, Mary Magdalene, John the Evangelist and Angels (1590–1600). In this image, El Greco's use of contrasting tones, a strong chiaroscuro (use of light and dark), limited palette, and his signature elongated figures exaggerate and heighten this miraculous moment. Placed in their traditional positions at his sides, Jesus' mother, Mary, and disciple John stand gazing at him. Mary Magdalene caresses the base of the cross. The cross, a deep dark brown, blends with the ground and into the background, thus pushing the glowing form of Christ's body to the foreground. Behind Christ are two angels, who seem to be raising him. Another angel hovers at his feet. The rhythms within the painting—moving up and down, forward and back—help convey the mystery of Christ's sacrifice.

It Is Finished

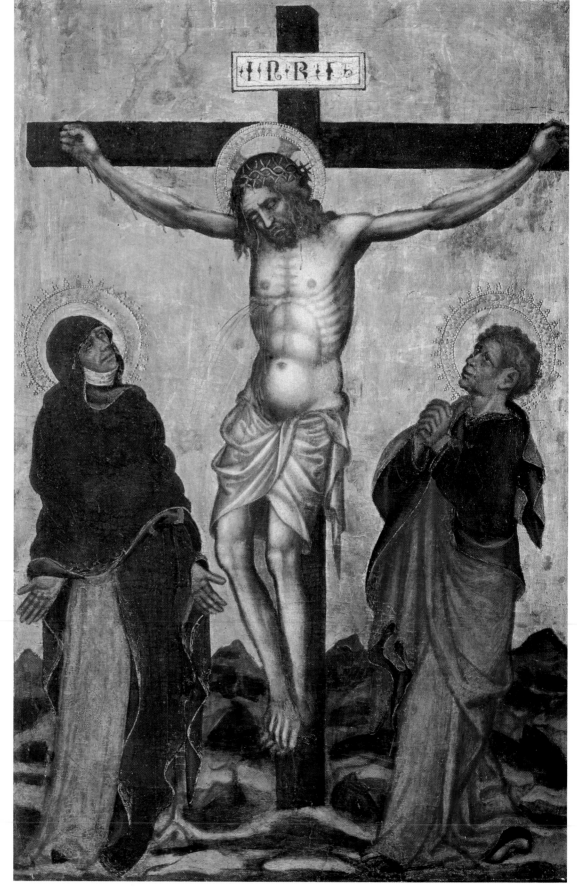

MICHELE GIAMBONO, Crucifixion *(1420–30). This reverent early Renaissance image of the crucifixion is painted on a panel. The top three-quarters of the painting are gilt, creating a radiant background. Set in a low landscape, the three figures are monumental. Mary looks up at her dead son with a gesture that seems to ask, "Why?" John clasps his hands in reverence for the solemnity of the moment. Christ's blood pours from his wounds in a dramatic display of both his suffering and the deliverance of the sacrament.*

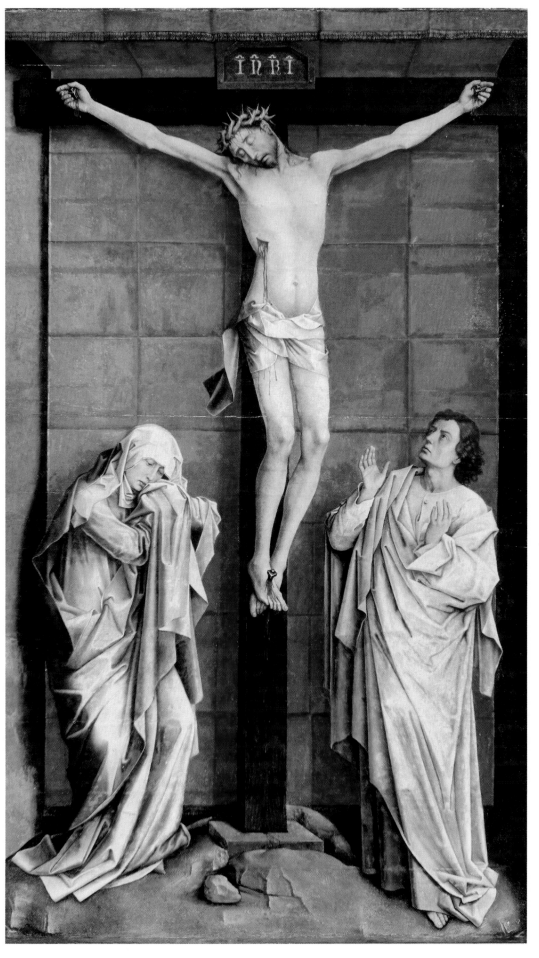

ROGER VAN DER WEYDEN, Crucifixion with St. John and the Virgin Mary *(1460)*. *This simple scene was originally painted for a Carthusian monastery. The crucified Christ is flanked by his mother, Mary, and his disciple John. Christ is placed on a cross that merges with the heavy red wall behind him. This contrasts with his fleshy skin and near weightlessness, emphasizing his death and movement from the physical plane to the spiritual. Additionally, the contrasting background heightens the wound from which his blood pours. Clad in grayish-white garments similar to the Carthusian garb, Mary and John are more sculptural and weighty than Christ, affirming their presence on earth.*

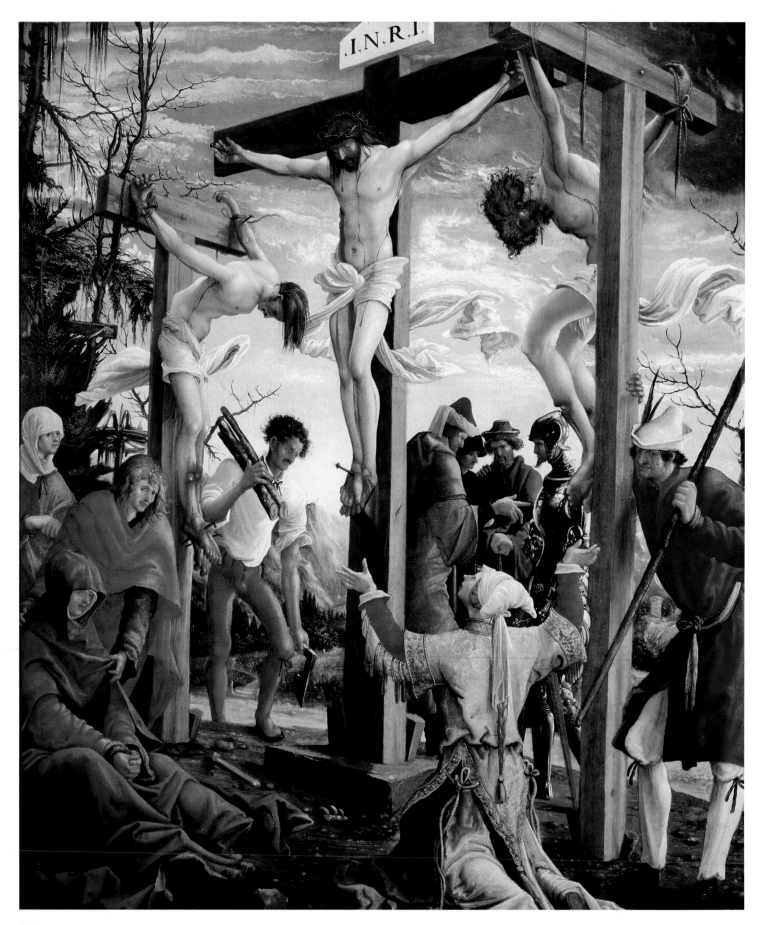

ALBRECHT ALTDORFER, Crucifixion *(ca. 1515)* **(Opposite)**. *Altdorfer was interested in depicting the landscape, even in his sacred work. In this* Crucifixion, *the right outer wing of the Sebastian Altarpiece, Altdorfer sets the scene in a northern landscape. Placing the three tall crosses at ninety-degree angles to one another, with Christ at an angle in the center, Altdorfer maximizes the space of the image so he can paint a beautiful landscape and still capture the holiness and solemnity of the event. John, Christ's mother, and other mourners are at the base of the cross, while other spectators have left or are leaving. In the distance are mountains. An atmospheric, hazy sky suggests the advent of a new beginning.*

MASACCIO, The Trinity *(ca. 1425)* **(Right)**. *Painted for a wealthy donor family, Masaccio's fresco of* The Trinity *depicts the crucified Christ in an imagined architectural setting that penetrates the space of the wall. Mary, who gestures toward her son, and John the Evangelist flank Christ, who is placed within the arms of God the Father. The donors flank the entire scene, set outside the space occupied by the holy figures. They are placed directly above an image of a sarcophagus upon which lays a skeleton. Together, the two realms of the fresco—the heavenly and the earthly—suggest the triumph of the spirit over the human world through Christ's sacrifice.*

A Family Mourns
The Deposition, Lamentation, and Entombment

Scriptural accounts of the events after Jesus' death are brief. All four Gospels record that Joseph of Arimathea (a member of the Sanhedrin—the Jewish high council—who had not taken part in condemning Jesus to death) petitions to Pilate for permission to remove Christ's body from the cross. It is important to remember that Jesus and his followers were Jews and therefore observed Jewish customs, one of which is to bury the dead as soon as possible after death. Pilate, in an act of compassion and generosity, grants permission. Joseph, along with Nicodemus, removes the body of Christ from the cross. (Nicodemus was a Pharisee, also a member of the Sanhedrin.) Artistic portrayals of this event are some of the most evocative images of the Passion. The heavy, limp dead body of Christ is borne by Joseph, Nicodemus, and sometimes other figures, and the emotional and physical weight of their task is palpable.

None of the figures that remove the body in the deposition seem to be aware that Jesus is only humanly dead, and thus their pain and mourning is profound. They do not understand that he is dead and yet undead. Only the physical, *human* body of Jesus is deceased—his human role on earth having been completed. But, to the unaware, his death seems final.

No image expresses the depth of grief more than the Pietá, in which the Virgin Mary cradles her dead son in a manner that revisits images of the pair as the Madonna and Child. There is no scriptural account of Mary holding her son this way, but the images lend an emotive sense of humanity to the Passion. Other images of the pain felt by Jesus' mourners include a penitent Mary Magdalene kissing the bloody feet of Jesus and followers or disciples swooning in agony or sorrowfully holding their head in their hands.

As a customary burial practice, Christ's body is anointed with oils and spices, wrapped in a linen shroud, and placed in a tomb made out of living rock, one that had never been used for a burial. This tomb, or holy sepulchre, is a figurative cocoon. It is where he changes from the human figure of Jesus to the resurrected figure of the Christ.

Having retraced Christ's steps, suffering, and death through prayer—and aided by provocative images—parishioners of the Renaissance and Baroque period were given the opportunity to fully prepare their hearts and souls for the coming event of Easter: Christ's resurrection from the dead.

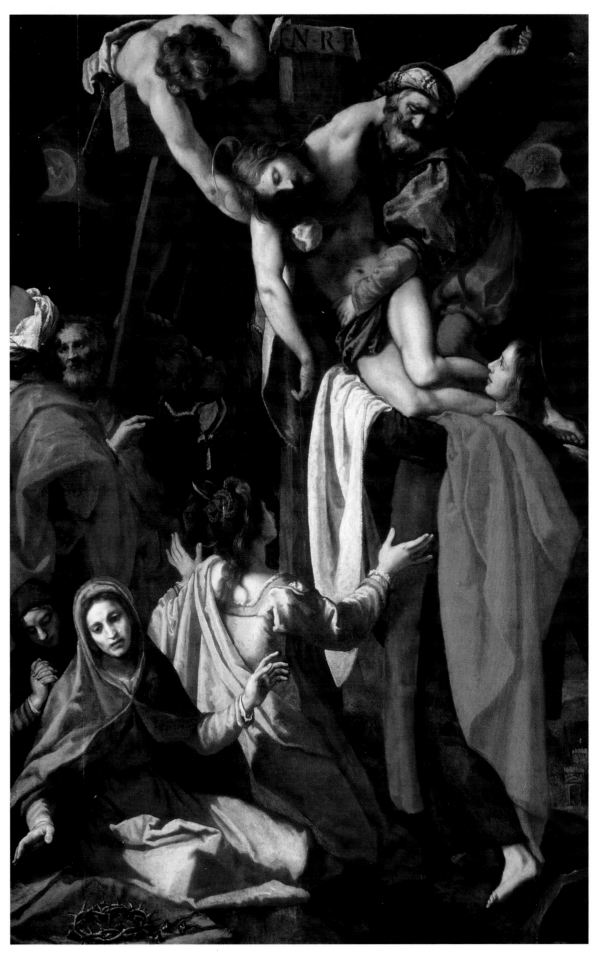

LUDOVICO CIGOLI, The Deposition from the Cross (1600–08). This compact, brightly illuminated scene is set against a dark background. Christ's crown of thorns and the nails that bound him to the cross, the instruments of his Passion, are in the front of the painting, to the left. His mother, seated on the ground, looks at and reaches for them. Her gesture is echoed by Mary Magdalene, who reaches toward the body of Christ.

Now there was a good and righteous man named Joseph, who, though a member of the council, had not agreed to their plan and action. He came from the Jewish town of Arimathea, and he was waiting expectantly for the kingdom of God. This man went to Pilate and asked for the body of Jesus. Then he took it down, wrapped it in a linen cloth, and laid it in a rock-hewn tomb where no one had ever been laid. It was the day of Preparation, and the sabbath was beginning. The women who had come with him from Galilee followed, and they saw the tomb and how his body was laid. Then they returned, and prepared spices and ointments. On the sabbath they rested according to the commandment.

Luke 23:50–56

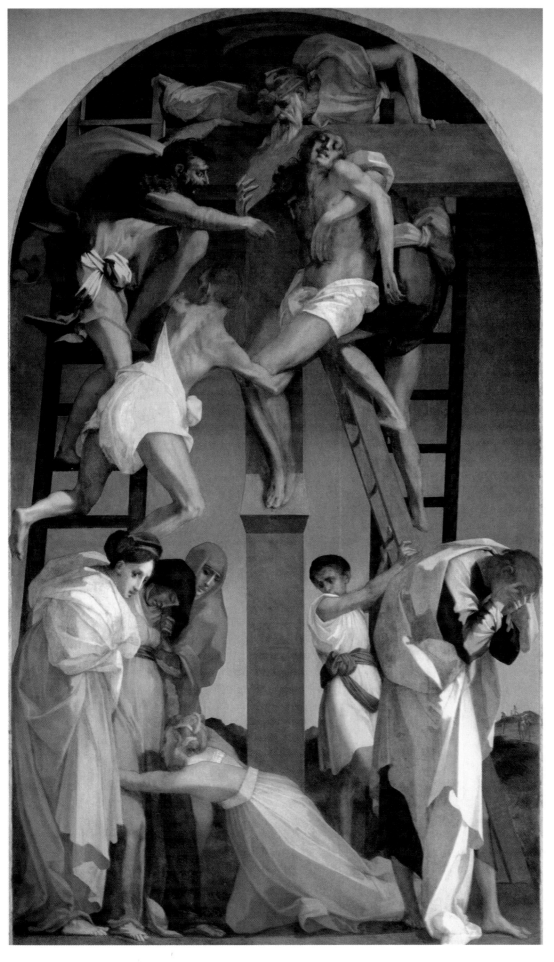

Rosso Fiorentino, The Descent from the Cross (1521). Fiorentino uses a bright palette and elongated forms to heighten the impact of this emotional event. A serpentine movement flows through the bodies of the figures removing Christ from the cross, then through his body, and down to the figures below. This is in contrast to the strong lines of the cross and ladders. Most of the figures are in warm tones—reds, yellows, and peaches— except Christ, whose body is a cool greenish-gray color. Like her son's dead body, Mary is also in gray, the two of them visually connected through color.

99

A Family Mourns

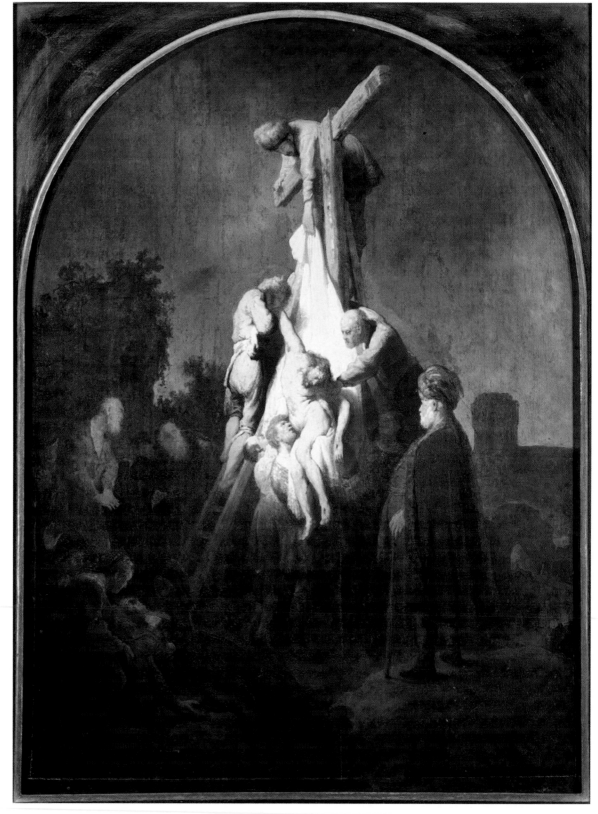

REMBRANDT HARMENSZ VAN RIJN, Descent from the Cross (1634). In a darkened landscape, the limp, heavy body of Christ is quietly removed from the cross. Instead of emphasizing the mourners in this scene, Rembrandt focuses on the sacrifice. Most of the figures are set in shadows, but a bright light shines upon Christ. The cross itself, still stained with blood, is a reminder of the meaning of the Passion.

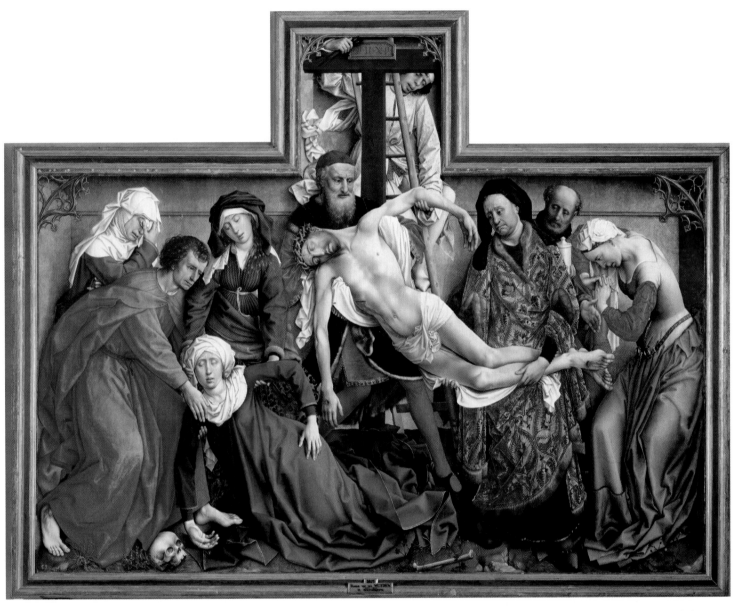

ROGER VAN DER WEYDEN, Deposition *(1435–50). This work was commissioned for an altarpiece, and the discomfort associated with death and mourning is heightened by the artist's use of space. Weyden places the cross at the top, where a male figure on the ladder helps Joseph of Arimathea release Christ's body from the cross. Nicodemus stands in the background holding the oil used to anoint the dead. Christ's awkwardly positioned body links the left and right sides of the painting. Mary Magdalene is at his feet, nearly bowing in reverence, and Jesus' mother faints, echoing his position. The hands of Mary and Christ almost touch, and visually we are led to her other hand, which is almost touching the skull of Adam. This is a reminder that Jesus was born through Mary to redeem the sin caused by Adam.*

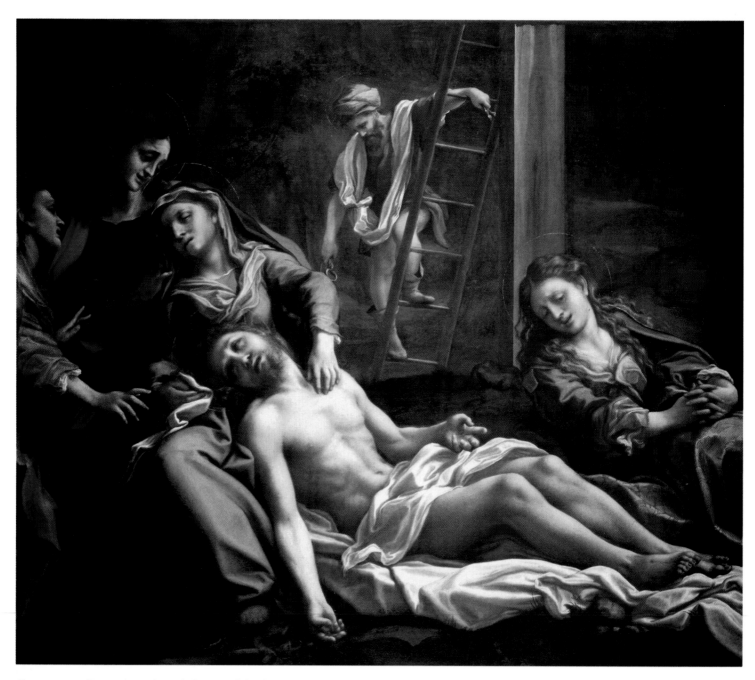

CORREGGIO, Deposition *(1525). Scenes of the deposition allowed artists to express the emotional impact that Christ's death had on the people he was closest to. Here, Correggio paints a scene where both Christ and Mary are tragic figures. Christ's head is placed in his mother's lap, his body propped against her. Weakened by her own grief, Mary is physically and emotionally supported by two other women. Mary Magdalene sits at Christ's feet, her hands clasped in prayer, her face red from crying. The entire foreground is about the delicate emotions shared and expressed by the women, while in the background Nicodemus takes care of the duties associated with preparing the dead. Everything in his posture suggests that he, too, is grieving.*

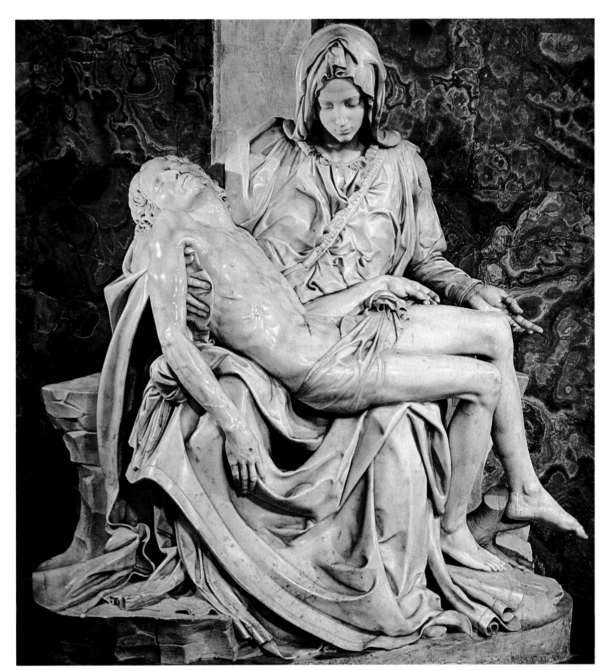

MICHELANGELO BUONARROTI, Pietá (1498–99). Michelangelo's Pietá, carved in marble, is a delicate portrayal of this intimate moment between mother and son. A young, fair Mary sits cradling Jesus. She leans back to absorb the weight of his body. The genius of the piece can be seen in the way Michelangelo turns stone into flesh, as the fingers of Mary's right hand press into Jesus' upper rib cage as she draws him into her. Here, Jesus is not the Christ, but Mary's child. The work brings to mind images of the Madonna and Child, focusing not on grief and anguish but on love and tenderness.

GIOVANNI BELLINI, San Giobbe Altarpiece (1485). This altarpiece is an example of the many images of the Madonna and Child. Here, Mary and Jesus are cast in the role of Madonna and Child Enthroned, where Mary is considered the "Queen of Heaven" because of her role as the vessel for bringing Jesus into the world. The position of the Christ child on Mary's lap can be compared to Michelangelo's Pietá, in which he utilizes the traditional imagery of the holy pair.

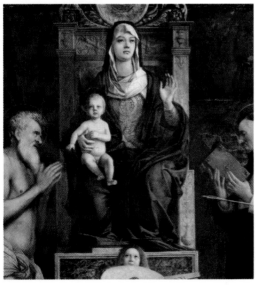

A Family Mourns

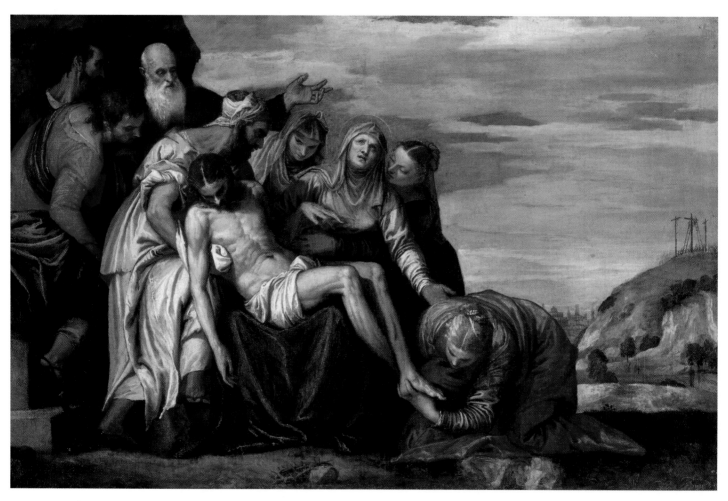

PAOLO VERONESE, Deposition *(ca. 1580). Veronese's* Deposition *combines the emotional gravity of a Pietá with the removal from the cross. In this scene, the cross is far removed, off in the distance on the right. The glorious sunset is in striking contrast to the darkened cliff where the mourners have assembled. Placed in his mother's lap, and supported by John the Evangelist, Jesus' heavy body still glows with the radiance of his divinity. Mary reaches out toward the grieving Mary Magdalene, who weeps at Jesus' feet.*

GIAMBATTISTA TIEPOLO, The Way of the Cross: Station 13, Christ Is Taken Down from the Cross *(1749)* **(Opposite)**. *This emotionally gripping scene highlights the human tragedy within the Passion. The figures are clustered around the base of the cross, and Christ's body is gently placed on the shroud by Joseph of Arimathea and Nicodemus. Mary is comforted by another figure, whose identity is unknown. The striking element in the painting is the bright light shining only on Christ's body and the immediate area around him, in contrast to the darkening landscape in the background and the deep shadows of the foreground. The spectator at the left, an apostle who buries his face, also serves as a stand-in for the viewer, drawing us into the scene as a witness to this tragic event.*

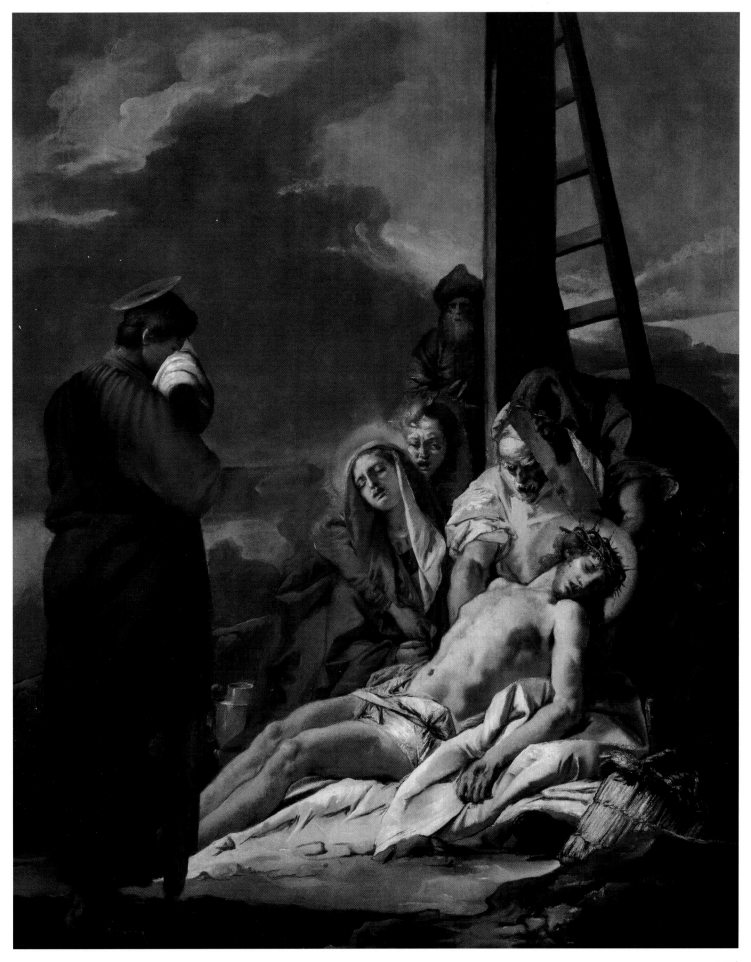

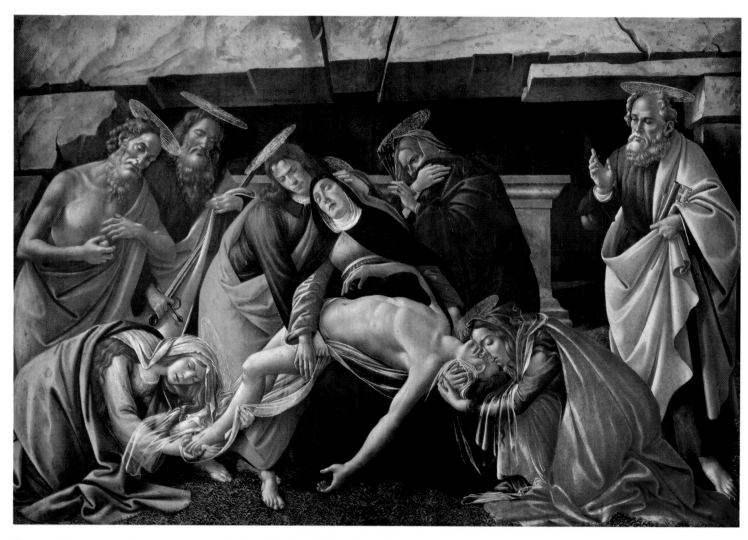

SANDRO BOTTICELLI, Lamentation over the Dead Body of Christ (Pietá) *(1498). Positioned in front of a small cavelike opening, the figures in Botticelli's image create a swaying rhythmic motion. Flanking Christ are Mary Magdalene, who caresses Jesus' feet, and Salome, who kisses his cheek. His arched body and the crouching figures of the two women create a smooth, wavelike motion set against the sharper movements of the figures behind them. Mary, Jesus' mother, leans against John, so struck with grief that she can no longer support her son's body, which seems to be slipping off her lap. Two other saints and the third Mary lean in toward the central group. Saint Peter, with key in hand, gestures as if he's delivering a blessing.*

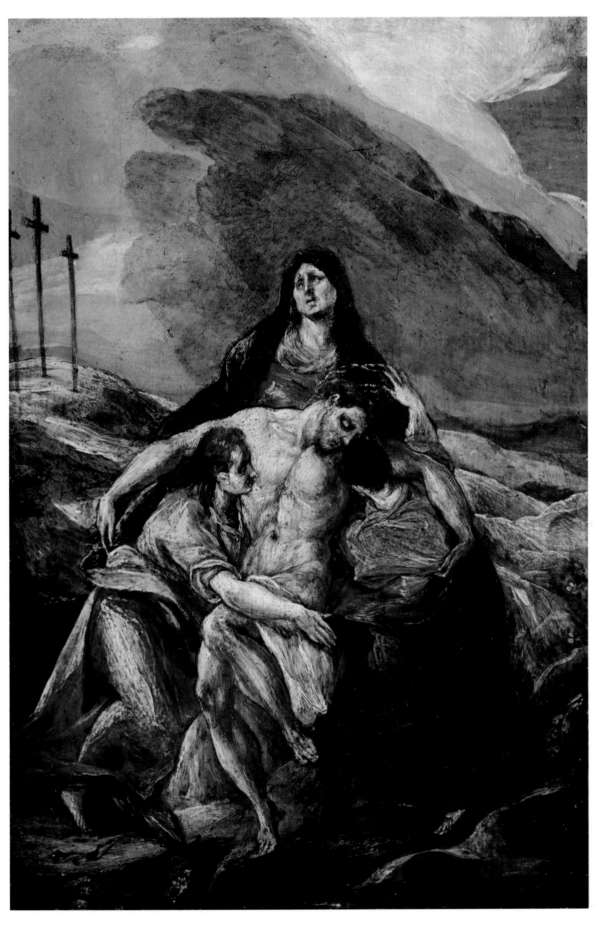

DOMENICO
THETOCOPULI, CALLED
EL GRECO, Lamentation
(1565–70). El Greco
uses color and
brushstroke to
emotionally heighten this
image of the lamentation.
Christ's contorted body
reminds us of his
suffering on the cross.
His mother is painted as
a solid figure and seems
to almost emerge from the
earth itself. She not only
supports the weight of
her son, but also of John
and Mary Magdalene,
who embrace Christ. His
arms drape around them
in stark contrast to their
previous position on the
cross. The swirling
bluish-gray clouds
further enhance the
gravity of the scene.

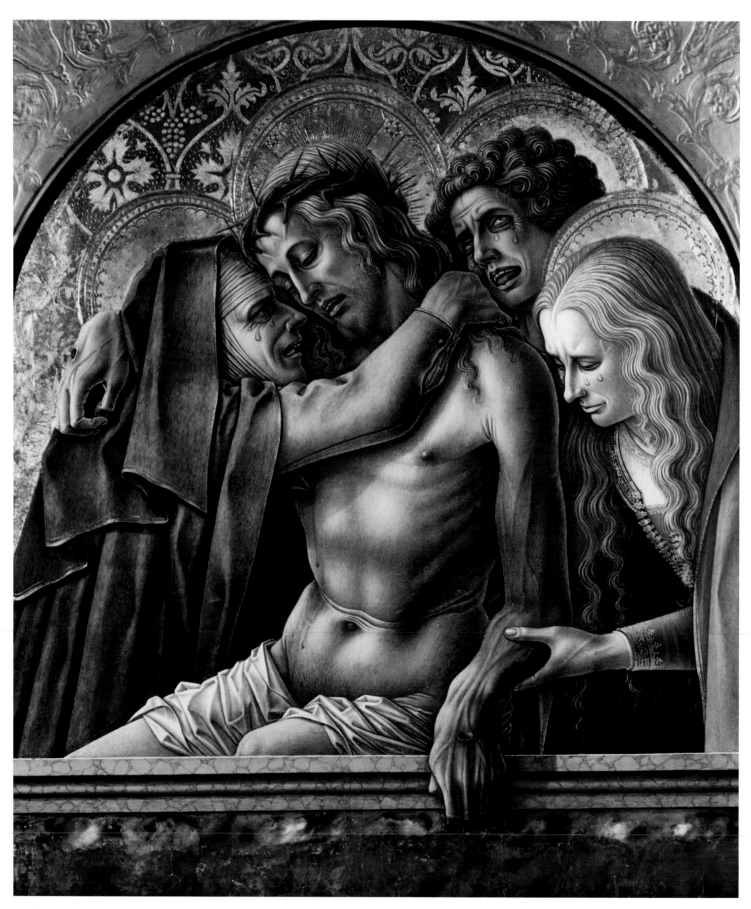

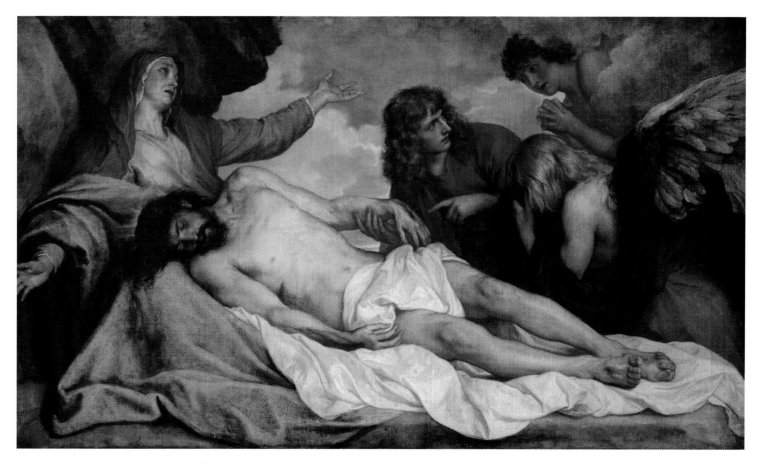

ANTHONY VAN DYCK, Bewailing of Christ *(1634–35). Mourned by both humans and angels alike, the dead Christ rests on the ground with his head in his mother's lap, like a sleeping child. John holds his arm, showing his wounds to the angels. The figures are set in a cave with the opening behind them. The bright blue sky, evocative of heaven, gently foreshadows Christ's resurrection.*

CARLO CRIVELLI, Pietá *(ca. 1485)* **(Opposite)***. Pain, anguish, and despair are depicted in this highly emotional image. Christ's body is almost grotesque, his torso elongated and deformed from the crucifixion, the veins in his arms and hands bulging against the skin. In disbelief, Mary Magdalene weeps and holds Jesus' left arm. His right arm drapes around his weeping, wailing mother. John, set behind, also cries aloud. Christ's body is propped upon the marble platform, at once being displayed and making reference to the sarcophagus (stone coffin) in which he will be buried.*

A Family Mourns

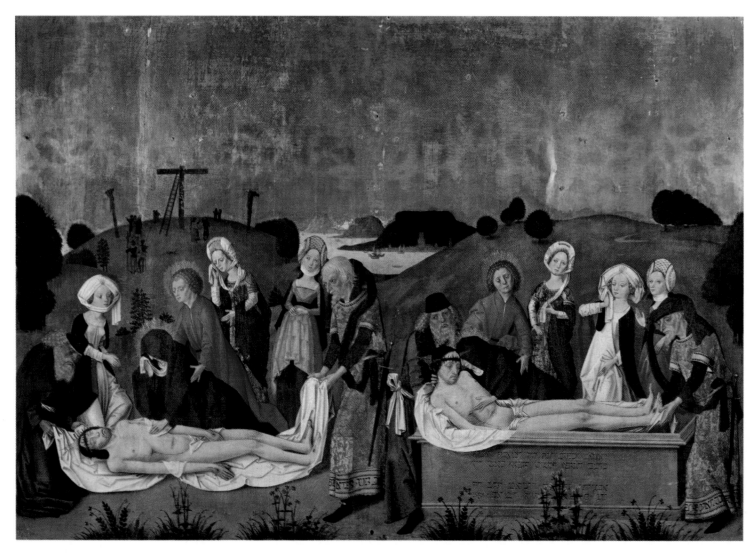

KASPAR ISENMANN, Deposition and Burial of Christ *(1465)*. This altarpiece shows two scenes in one continuous image. On the left, Joseph and Nicodemus tend to Christ's body. The difficulty of their task is reinforced by the three crosses on the distant hill. John comforts Mary, who weeps over her son, touching him. Behind the intimate group, three other women in fifteenth-century dress bear witness to the event. Moving to the right side of the painting, Christ's mother says a final good-bye, embracing her son as he is placed into a sarcophagus.

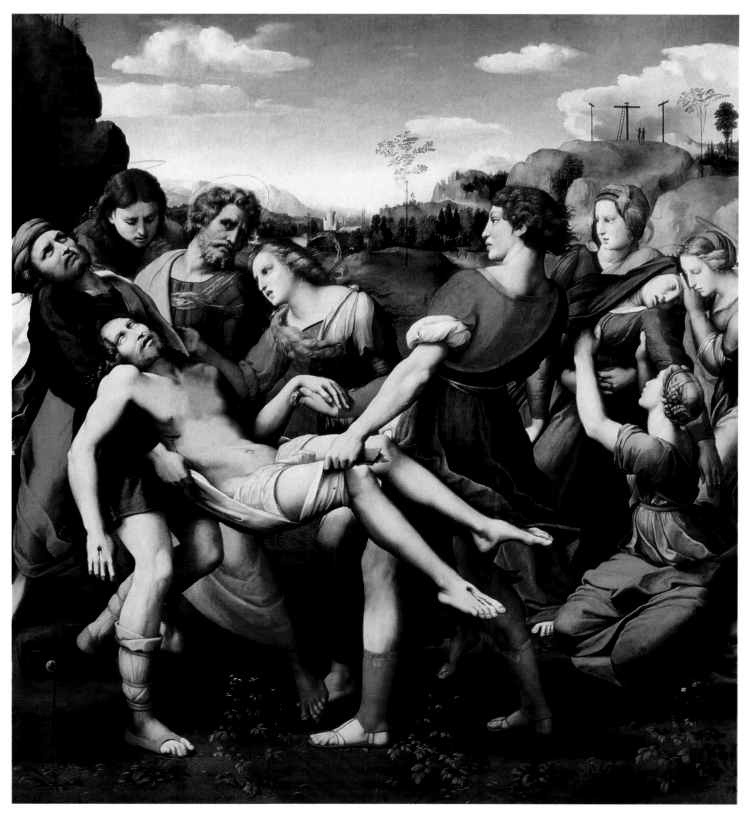

RAPHAEL SANZIO, The Entombment *(1507). The struggle and labor of burial is expressed in this work by Raphael. Having traveled far from Golgotha, the site of the crucifixion (which can be seen in the distance), the men hoist Christ's dead body as they prepare to enter the tomb. Mary, here depicted as a maiden, walks along with them, holding her son's hand. The small group of mourners is included as a contrast to the large mob of spectators that grew along Jesus' walk to Golgotha and watched the crucifixion.*

A Family Mourns

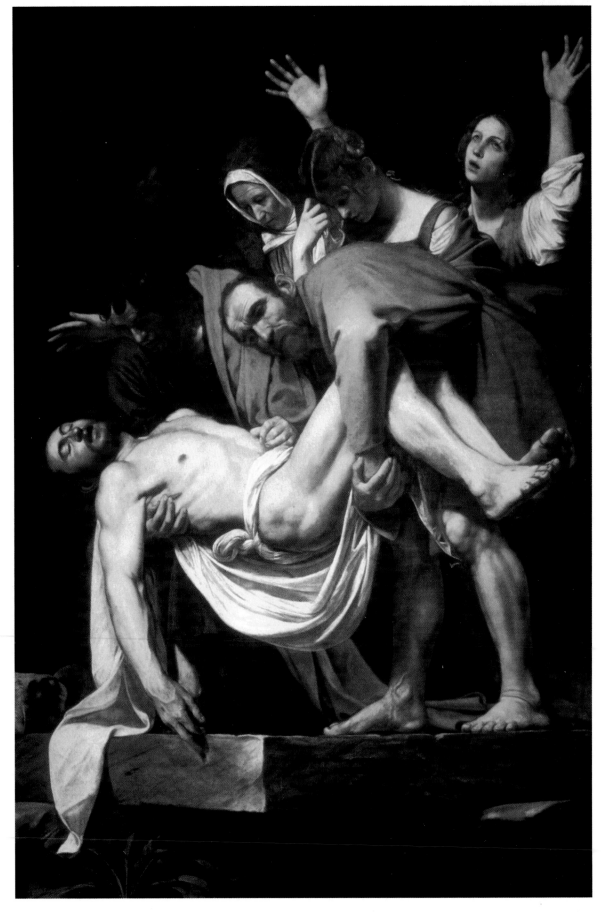

MICHELANGELO CARAVAGGIO, The Deposition/The Entombment (1602–04). Caravaggio uses his signature chiaroscuro (use of light and dark) to depict the physical and emotional gravity of this scene. A strong diagonal leads from Mary Magdalene's raised arms through the bowed heads of Salome and Mary, then through the bent position of Joseph of Arimathea and along the body of Christ. Christ's body is heavy and limp, indicated by the struggle with which Joseph holds his knees. Jesus' right arm and part of the shroud hang, touching the stone platform on which the group stands.

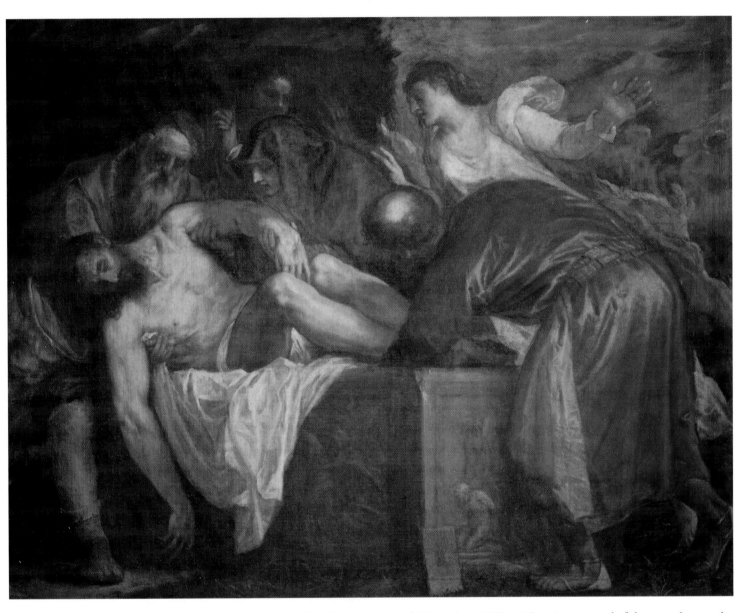

TITIAN (TIZIANO VECELLI), The Entombment of Christ *(ca. 1566). In Titian's portrayal of the entombment, the space around the action is dark except for a small hint of blue sky. The men lower Christ's body into a sarcophagus that seems to be too small for him. This suggests that his death was an unexpected event, and thus they had no time to adequately prepare. While Mary holds her son's wounded arm, an angel comforts her.*

A Promise Fulfilled
THE RESURRECTION

There were no human witnesses to Jesus' resurrection. Nor is there a scriptural account of what occurred while Jesus was entombed. Thus, Renaissance and Baroque artists were left to their own imaginations to interpret the time between Jesus' burial and his resurrection as the Christ.

The Gospels mention that Mary Magdalene and other women visit his tomb daily and leave offerings of spices and oils. Where the four scriptural accounts depart from one another is about which person (or people) actually makes the Easter discovery. John says that Mary Magdalene does it alone. Luke states that Joanna and Mary, the mother of James, accompany Mary Magdalene, and Mark includes the presence of Salome. Artists have taken license with the event, depicting a range of figures that are part of the discovery.

In any event, it is agreed upon that on the third day after Jesus' death the open tomb is discovered by, at the very least, Mary Magdalene, who fears the worst—that the tomb has been raided. Within the tomb, a confused, distraught Mary finds an empty shroud and one or two angels (scriptural accounts differ), who are sometimes visualized in Renaissance and Baroque art as soldiers or guards. Mary weeps, thinking that Jesus' body has been stolen. The angels, whom we can assume were divine messengers or servants sent to aid in and witness the resurrection, tell her not to seek the living among the dead and inform her that the Son of Man was crucified, died, and is now risen, just as Jesus had preached in Galilee. Approached by the resurrected Christ, who reminds her not to touch him, saying, "*Noli me tangere*," Mary is told that the promise of his rising from the dead has been fulfilled and that she must go and tell the disciples. Jesus explains that the reason she cannot touch him is because he has not yet ascended to his Father (John 20:17).

Mary Magdalene spreads the word and receives a variety of reactions from the disciples until they see and hear for themselves that Jesus has risen. The task of Jesus' resurrection is not complete until his disciples recognize him—they still need physical proof and confirmation of his rising in order to gain faith in the lessons that he taught and the prophesies that he preached. Once they see the marks of his wounds from the crucifixion, they believe. Then the remaining eleven (Judas has died) compel the risen Jesus Christ to partake in a meal with them. So just as they ate together at the Last Supper, the disciples again dine with Christ, who delivers to them the first communion.

Agnolo Bronzino, Resurrection *(1550)*. *Bronzino's depiction of the resurrection combines various elements of the risen Christ's journey. The central figure of the victorious Christ hovers slightly in front of the other figures. He carries a banner, the staff of which is a cross. Below him are the dead who will not be freed from hell. Two angels precede Christ, as if in a triumphant processional, while above him are a host of angels, as well as humans who have been raised to the heavens.*

115

When the sabbath was over, Mary Magdalene, and Mary the mother of James, and Salome bought spices, so that they might go and anoint him. And very early on the first day of the week, when the sun had risen, they went to the tomb. They had been saying to one another, "Who will roll away the stone for us from the entrance to the tomb?" When they looked up, they saw that the stone, which was very large, had already been rolled back. As they entered the tomb, they saw a young man, dressed in a white robe, sitting on the right side; and they were alarmed. But he said to them, "Do not be alarmed; you are looking for Jesus of Nazareth, who was crucified. He has been raised; he is not here. Look, there is the place they laid him. But go, tell his disciples and Peter that he is going ahead of you to Galilee; there you will see him, just as he told you." So they went out and fled from the tomb, for terror and amazement had seized them; and they said nothing to anyone, for they were afraid.

Mark 16:1–8

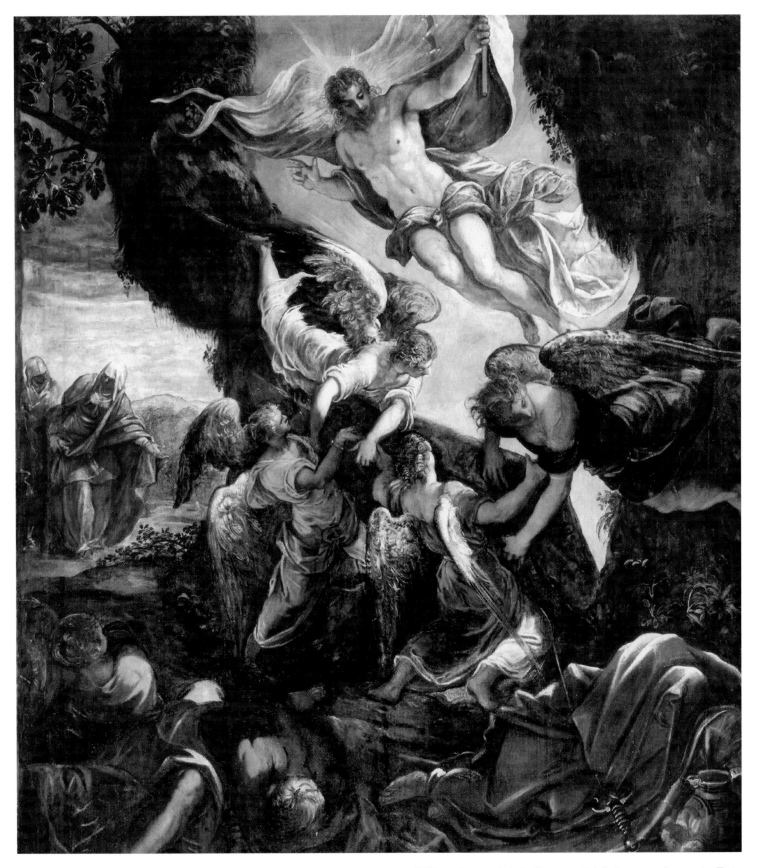

JACOPO ROBUSTI TINTORETTO, Resurrection of Christ (1579–81). As four angels lift the sarcophagus (coffin) lid, Christ triumphantly floats heavenward. Meanwhile, the women who kept watch over the cave approach in the distance. It is early morning. As the sun rises, so does the Christ, symbolizing the dawn of a new day and a new era—one in which humanity is reunited with God and where eternal sleep is replaced by everlasting life.

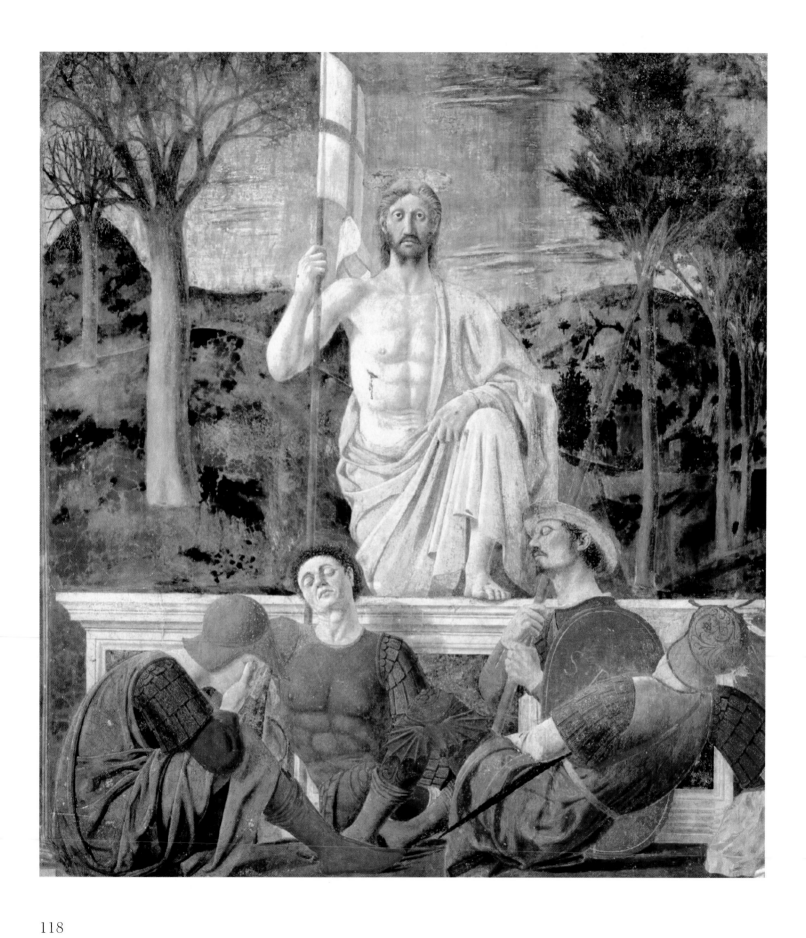

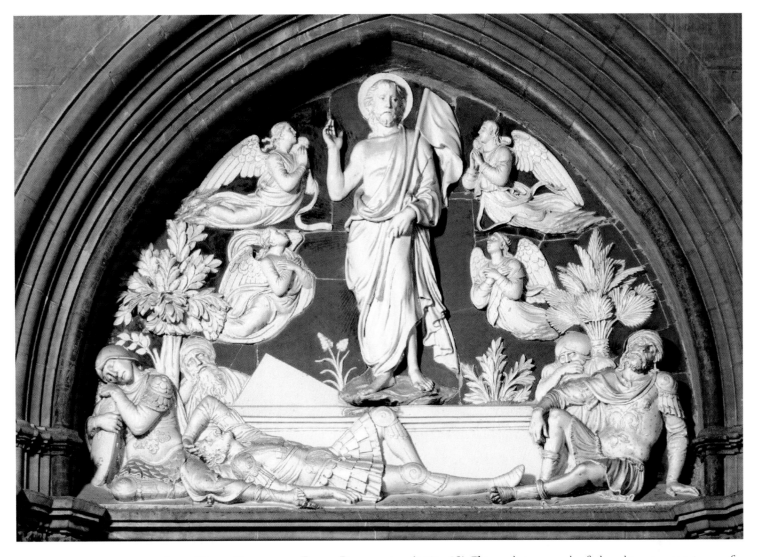

LUCA DELLA ROBBIA THE ELDER, Resurrection *(1431–38). This sculpture, made of glazed terra-cotta, is one of a pair that sits above the sacristy doors at the duomo, Santa Maria delle Fiore, in Florence. Surrounded by angels, a triumphant Christ stands on a cloud, holding a victory flag and gesturing toward the heavens. The cloud hovers just above the sarcophagus, which is surrounded by sleeping guards. Della Robbia includes various symbols of Christ and his Passion. Most notable are the oak on the left—a symbol of faith, virtue, and the triumph of Christianity over adversity—and shafts of wheat on the right—a symbol of the Eucharist.*

PIERO DELLA FRANCESCA, The Resurrection of Christ *(1450–63)* **(Opposite)**. *A solemn, stern Christ stands victorious, having emerged from his coffin. Vanquishing eternal death, he places his left foot upon the tomb and bears the banner of Christian victory. Set within the landscape, rather than within the burial tomb, the scenery suggests a return to paradise with Christ as the new Adam, sent to undo the original sin. His wound bleeds as a symbol of the Passion, his sacrifice, and the Eucharist. Four guards sleep beside the tomb, unaware of Christ's return. This further suggests the triumph of Christianity over adversity from the secular world.*

A Promise Fulfilled

MICHELANGELO BUONARROTI, The Resurrection of Christ (ca. 1525). This work is believed to be one of several designs done by Michelangelo for a Resurrection in the incomplete Medici Chapel in Florence. Using red chalk, Michelangelo presents a heroic, beautiful image of Christ, who emerges victoriously from his sarcophagus (stone coffin). With minimal lines, color, and details, the movement of Christ's angelic assistants behind him and the piety of two other figures in front of him are depicted with startling realism.

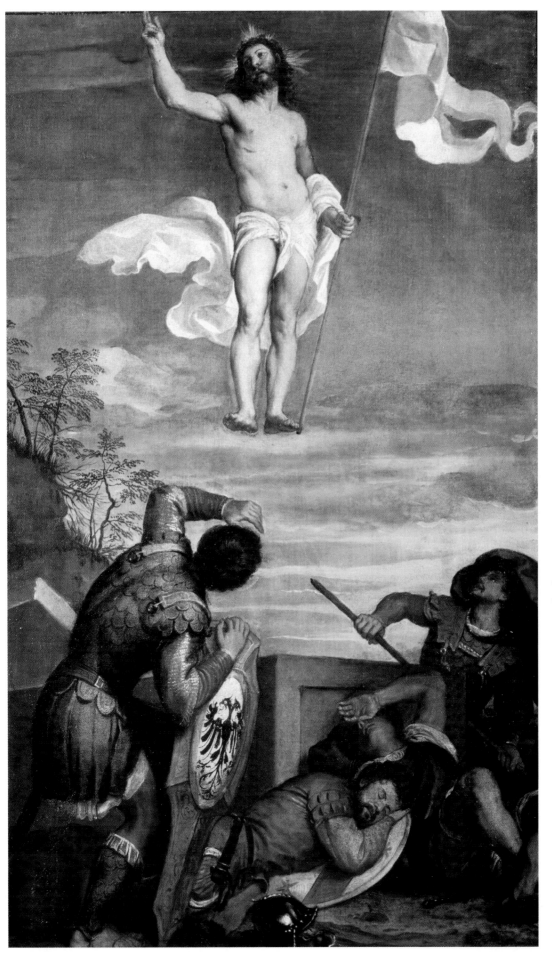

TITIAN (TIZIANO VECELLI), Resurrection (1560s/70s). One of Titian's late works, this image is of a strong, risen Christ. Depicted as a hero, Christ firmly stands between heaven and earth, one hand bearing the banner of Christian victory, the other raised in a powerful motion. Behind him the sun begins to rise, suggesting that he is the sun—the light of the world. Unable to behold his divinity, the soldiers in the foreground cover their eyes or pull away.

121

A Promise Fulfilled

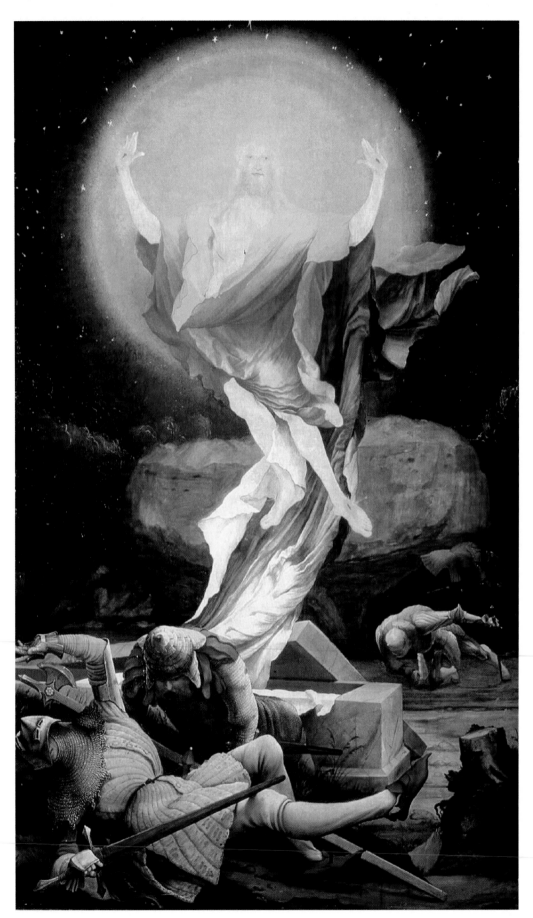

MATTHIAS GRUENEWALD, The Resurrection of Christ *from the Isenheim Altarpiece (1512–16). In this panel from the Isenheim Altarpiece, Gruenewald shows the power and force of Christ's triumph through a radiant spectacle. Having vanquished death, Christ rises out of his tomb. The unrepentant are depicted here as soldiers unable to withstand his radiance. The risen Christ displays his wounds as a reminder of his sacrifice on the cross. His spirituality is enforced by the mystical sunlike orb that simultaneously envelops him and radiates from him.*

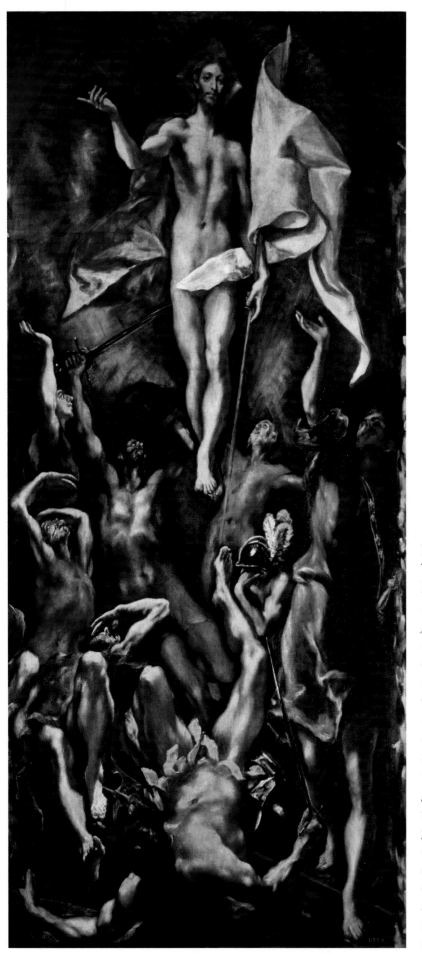

DOMENICO
THETOCOPULI, CALLED
EL GRECO, *Resurrection
(1577–79). Emerging
from hell, Christ leaves
behind the eternally
damned and takes with
him the souls of the good,
who slowly rise after him.
Pure and naked, he
ascends, carrying a
stark-white banner.
Christ himself emits a
glowing light that
radiates in a swirling
pattern of brushstrokes
around him. No longer
scarred by the markings
of his torture and
sacrifice, Christ has
triumphed over physical
and eternal death.*

123

A Promise Fulfilled

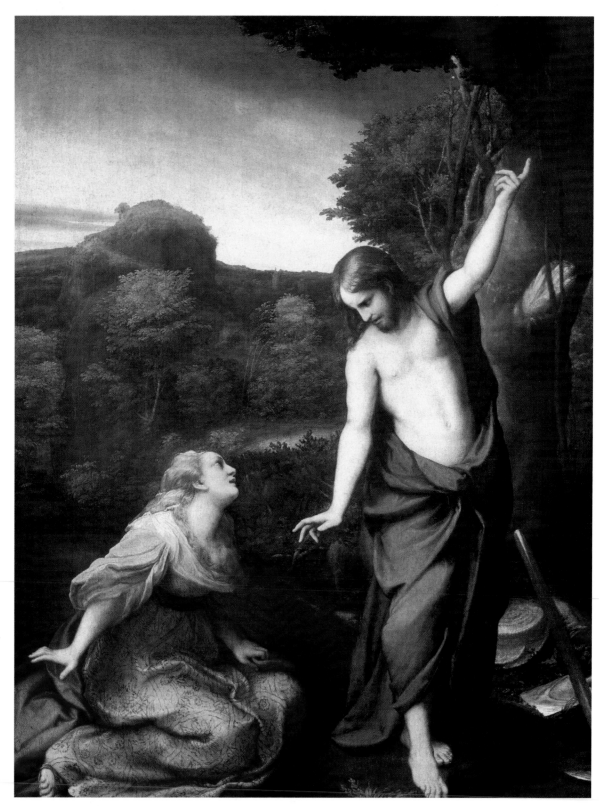

CORREGGIO, Noli me Tangere *(1525). Set in a beautiful, lush landscape, this is the scene where Mary Magdalene encounters the risen Christ. Having fallen to her knees in surprise and reverence, she leans in toward him. Christ turns to her and, with the tender gesture of his right hand, tells her, "Touch me not" (noli me tangere). As he points to the heavens with his other hand, Christ explains that his journey is incomplete, as he must still ascend into heaven.*

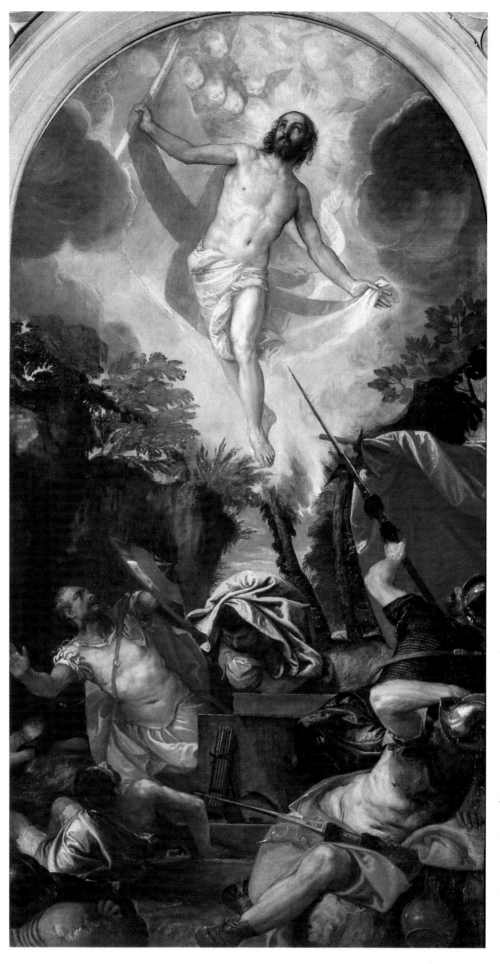

PAOLO VERONESE, The Resurrection of Christ (ca. 1584). Frightened human guards dressed as Romans lunge away from the glorious light surrounding Christ. One guard even aims a weapon at him, but Christ rises, untroubled by their actions. With his eyes directed toward heaven, Christ gently floats—his wounds healed—toward divine glory. The tumult of activity in the foreground is set against the peacefulness of Christ's expression and the heavens that open to welcome him.

A Promise Fulfilled

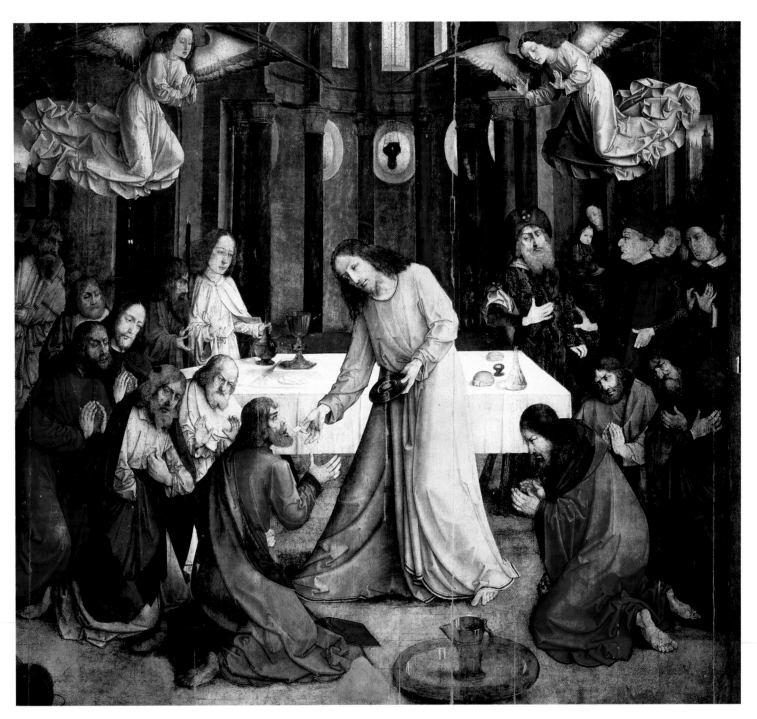

JOOS VAN GHENT, The Communion of the Apostles (1474). *Painted for the high altar of the Brotherhood of Corpus Domini, this image depicts not only the apostles receiving communion, but also the donor, Duke Frederico, and his entourage. Dressed in fifteenth-century Flemish garb, they stand to the right of the scene, which is set in the chancel of a church. Christ delivers the sacrament to his disciples, who kneel around and before him, bowing in reverence to their risen Lord.*

People of the Passion

Annas: Father-in-law of the high priest Caiaphas. Jesus was taken to the courtyard of his house the night of his arrest, and it was there Peter denied knowing Jesus.

Barabbas: A political terrorist and murderer who was released by the crowd when Pilate offered them a choice between him and Jesus.

Caiaphas: The Jewish high priest to whom Jesus was brought after his arrest and rushed trial. After admitting before Caiaphas that he was the Christ, Jesus was condemned to death.

Herod Antipas: This ruler of Galilee mocked Jesus and treated him with contempt. Neither defending nor condemning Jesus, Herod left the decision of his fate to Pontius Pilate.

James: One of Jesus' favored followers, he fell asleep while Jesus prayed at the Garden of Gethsemane and fled during his arrest, but he reunited with Jesus after the resurrection.

Jesus: Jesus of Nazareth is the figure whom Christians believe to be the Son of God incarnate, that is, God-in-the-flesh. Jesus had many titles ascribed to him, but the most common was Christ, which is Greek for messiah, meaning *anointed one.* To Christians, Jesus was (and is) God's promised Savior, the one who saved humanity from sin and death through his own life, death, and resurrection.

John: Like his brother James, John was one of Jesus' closest disciples. He, too, fell asleep at Gethsemane, fled during Jesus' arrest, and reconnected with Jesus after the resurrection. Jesus left his mother in John's care at the crucifixion.

Joseph of Arimathea: This respected member of the Sanhedrin (Jewish council) received permission from Pilate to remove Jesus' body from the cross and place it in his own tomb.

Judas Iscariot: This disciple betrayed Jesus for thirty pieces of silver. Judas brought the temple guards to the Garden of Gethsemane and identified Jesus by a kiss of greeting.

Malchus: After Jesus' arrest, Peter wielded a sword and cut off the ear of Malchus, a servant of the high priest. Jesus then healed his ear.

Mary: The mother of Jesus was present with her son throughout the events of his life, including his crucifixion.

Mary Magdalene: This devoted follower of Jesus was at the cross when he died and at the tomb when he was resurrected.

Nicodemus: A member of the Sanhedrin, he helped Joseph of Arimathea prepare Jesus' body for burial.

Peter (also called Simon Peter): One of Jesus' closest disciples. After Jesus was arrested, Peter cut off Malchus's ear and later denied that he knew Jesus.

Pilate: This Roman governor found no crime against Jesus, but he eventually succumbed to the angry crowd's call for Christ's crucifixion. Literally washing his hands before the public, Pilate claimed he was innocent of Jesus' death.

Satan: In the Bible, Satan is portrayed as the chief antagonist of God and humanity, the source of all evil. When Jesus was resurrected, he destroyed Satan's power over humanity, offering deliverance from Satan's control to every believer.

Simon of Cyrene: A passerby who was instructed to help Jesus carry his cross.

Veronica: A character not mentioned in the Bible, Veronica is said to have encountered Christ while he carried his cross. She wiped his face, and his image remained on her veil.

Index